THE SPIRIT OF
NATIVE AMERICA

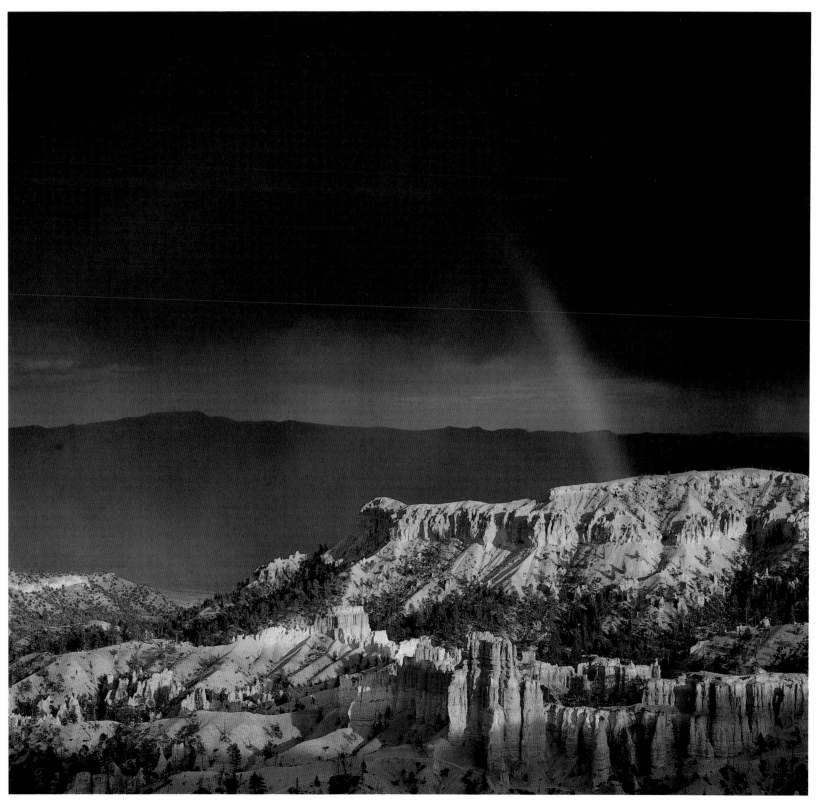

Bryce Canyon National Park, Utah (photograph by William Neill).

It is the general belief of the Indians that after a man dies his spirit is somewhere on the earth or in the sky, we do not know exactly where but we are sure that his spirit still lives. Sometimes people have agreed together that if it were found possible for spirits to speak to men, they would make themselves known to their friends after they died, but they never came to speak to us again, unless perhaps in our sleeping dreams. So it is with Wakan-Tanka. We believe that he is everywhere, yet he is to us as the spirits of our friends, whose voices we cannot hear.

CHASED-BY-BEARS, SANTEE-YANKTONAI SIOUX[1]

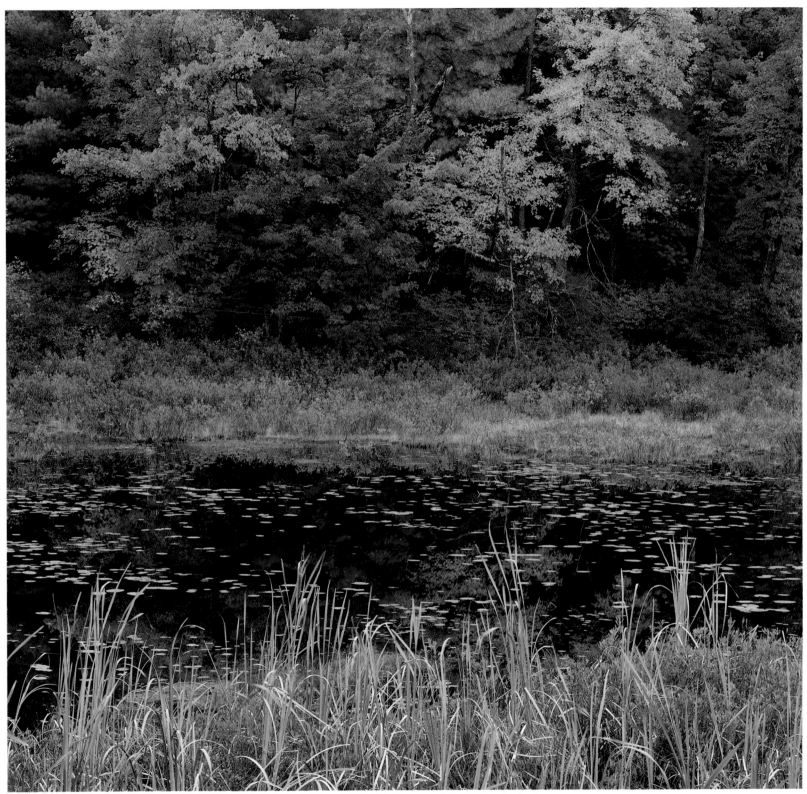

Crooked River, Maine (photograph by Willard Clay).

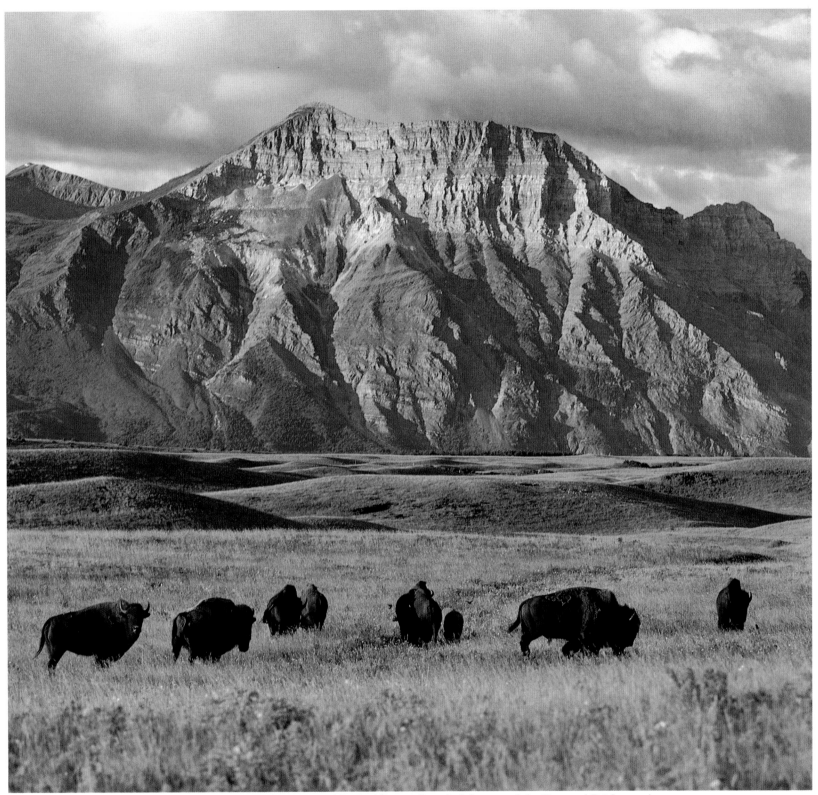

Buffalo, Waterton Lakes National Park, Alberta, Canada (photograph by Tom and Pat Leeson).

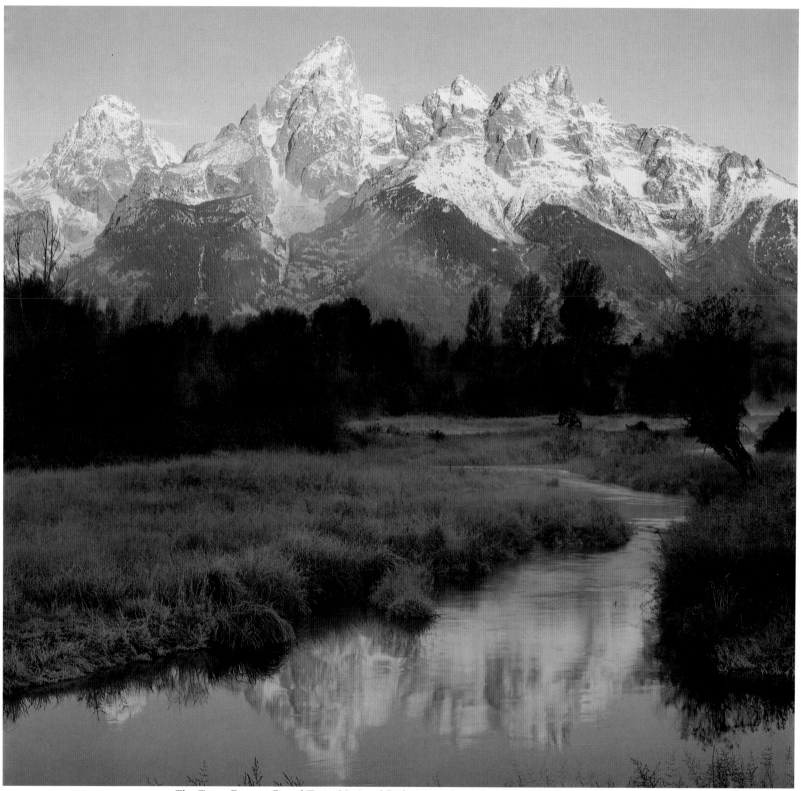

The Teton Range, Grand Teton National Park, Wyoming (photograph by Pat O'Hara).

THE SPIRIT OF NATIVE AMERICA

BEAUTY AND MYSTICISM IN AMERICAN INDIAN ART

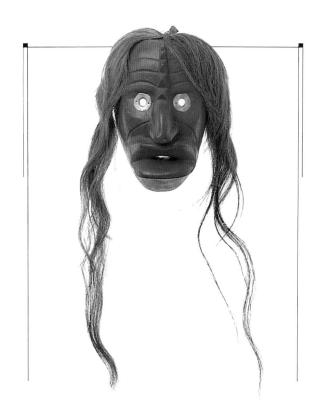

By Anna Lee Walters
Designed and Produced by McQuiston & Partners

Chronicle Books • San Francisco

To Sharlene

This book is alive with spirits. And one of the liveliest is the spirit of cooperation that has been present during its birthing—a process that involved people in Wyoming, Idaho, Utah, Arizona, and California. We are grateful to the board of directors of the Grand Teton Natural History Association for authorizing this project. Special thanks are due to the Association's executive director, Sharlene Milligan, for her help and enthusiastic support throughout. Our Native American guides at the Colter Bay Indian Arts Museum were Clyde Hall and Laine Thom. Their knowledge of the collection and their patience in answering questions made a difficult job much easier. Thanks also to the National Park Service people at Colter Bay for their courtesy during our visits. We also wish to thank Harry Walters of the Ned A. Hatathli Center Museum at Navajo Community College, Arizona, for his interest and professional advice.

John Oldenkamp and Cynthia Sabransky captured the essence of Native American spirituality with their stunning full-color photography. These photographs are in vivid contrast to the historical photos of Edward Curtis and Roland Reed obtained from the Museum of Man, San Diego, California. Special thanks go to Grace Johnson at the museum for her help in selecting those images. Robin Witkin's editorial work went far beyond the usual bounds of copyediting and made an important contribution to the text. To our friends at Chronicle Books—specifically Jack Jensen, David Barich, and Bill LeBlond—many thanks for the continued support. Finally, we owe a special debt of gratitude to the Jackson Hole Preserve, Inc. This foundation's generous financial contribution went a long way toward making this book possible.

Produced and designed by McQuiston & Partners, Del Mar, California; Edited by Robin Witkin; Photography by John Oldenkamp and Cynthia Sabransky; Mechanical production by Joyce Sweet and Kristi Paulson; Composition by TypeLink; Printed in Singapore by Toppan Printing Co., PTE., Ltd., through Palace Press, San Francisco.

Distributed in Canada by Raincoast Books
112 East Third Avenue
Vancouver, British Columbia V5T 1C8

Chronicle Books, 275 Fifth Street
San Francisco, California 94103

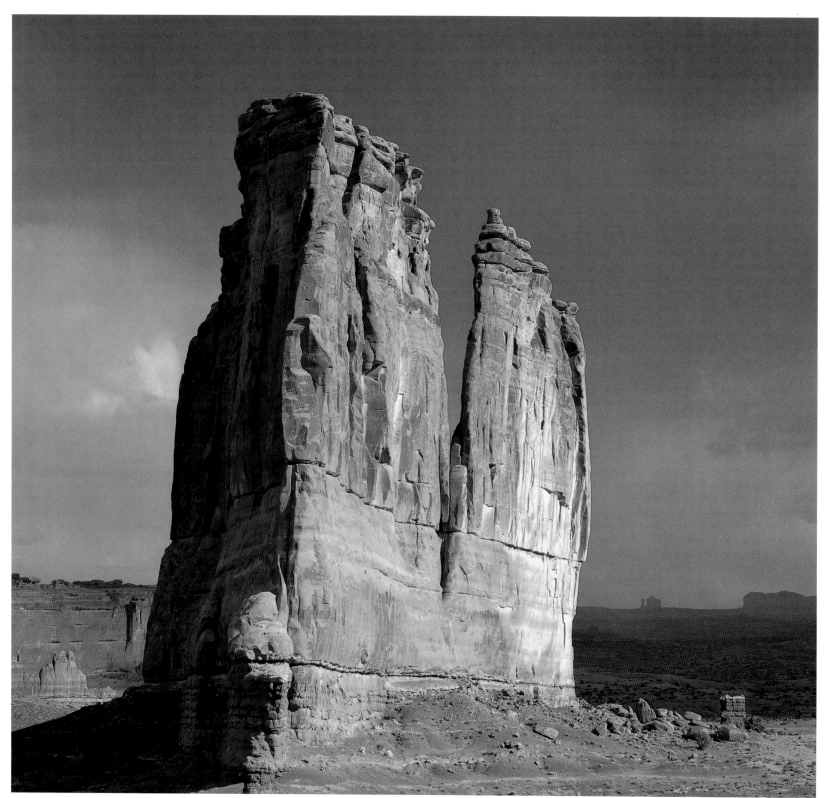

Courthouse Towers, Arches National Park, Utah (photograph by Willard Clay).

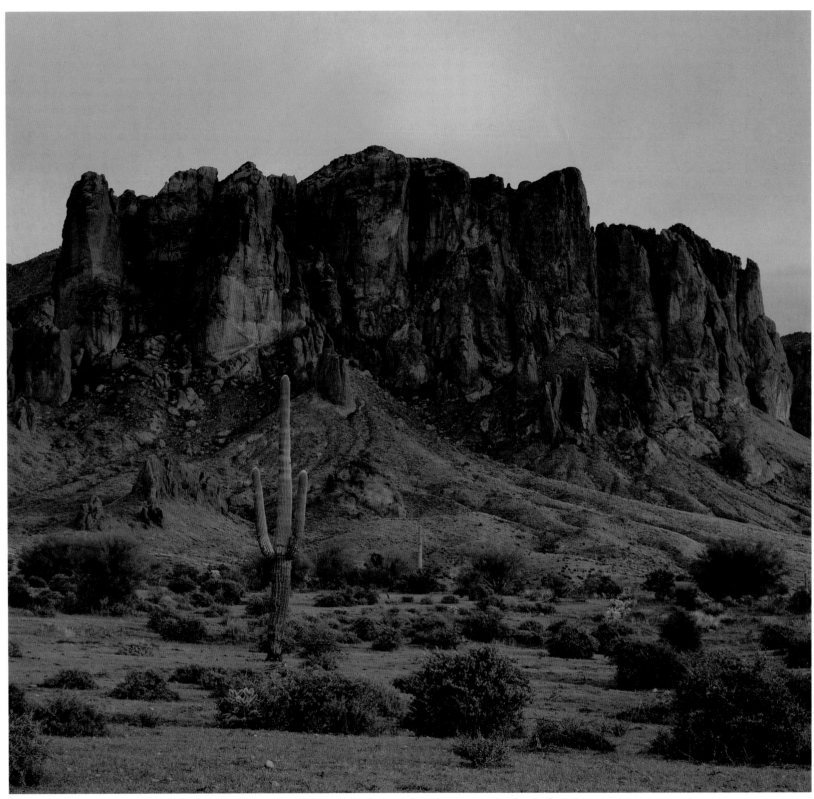

Superstition Mountains, Arizona (photograph by Willard Clay).

CONTENTS

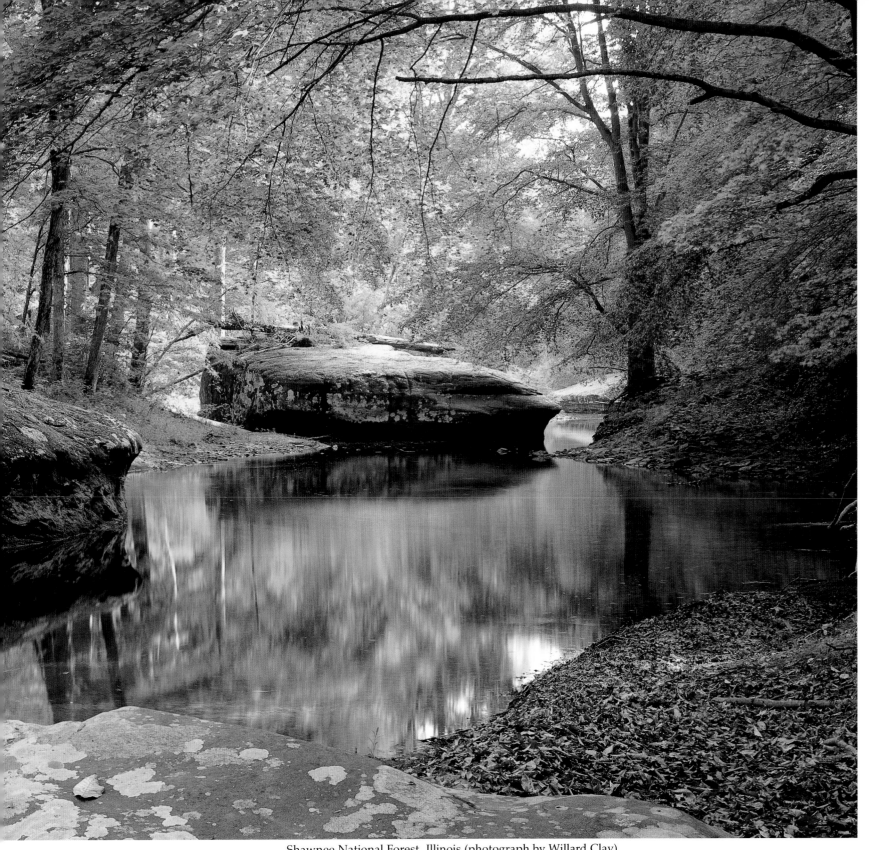

Shawnee National Forest, Illinois (photograph by Willard Clay).

Shoshone Lake, Wyoming (photograph by Pat O'Hara).

INTRODUCTION: ABOUT INDIANNESS

There has been an air of mystery about this book from the start. Much of it has to do with the mystical nature of the North American natives mistakenly called Indians. Some of this mystery is merely semantic. On the surface, this book is about art, or actually about artifacts that were created by these tribal people before and during the nineteenth century. Curiously, though, no word exists in the hundreds of Native American languages that comes close to our definition of art. What does this mean?

The answer is that the Indians did not set out to create art for its own sake. In traditional Indian thinking, there is no separation between art and life or between what is beautiful and what is functional. Art, beauty, and spirituality are so firmly intertwined in the routine of living that no words are needed, or allowed, to separate them.

Also, there is no Indian equivalent to our word *religion*. In the language of the Lakota Sioux, we find the term *Wakan-Tanka*, which translates to "Great Mysterious," but there is more to it than that. Black Elk, the much-quoted Lakota medicine man, had this to say:

Peace . . . comes within the souls of men when they realize their relationship, their oneness, with the universe and all its powers, and when they realize that at the center of the universe dwells Wakan-Tanka, and that this center is really everywhere, it is within each of us.²

To the Indians, all life is sacred, part of the infinitely renewable cycle that permeates and defines their cosmology. A critical element in this cycle is their relationship with the land—their reverence for Mother Earth. Before their first contact with European "settlers," the native tribes had no concept of land ownership. Rather, they viewed themselves as caretakers of a realm that defied individual ownership and, more important, was beyond value. This concept is expressed in typical Indian eloquence by a chief of the Blackfeet tribe:

Our land is more valuable than your money. As long as the sun shines and the waters flow, this land will be here to give life to men and animals; therefore, we cannot sell this land. It was put here for us by the Great Spirit and we cannot sell it because it does not belong to us.³

Before the encroachment of white "civilization," Indians customarily gave away food, clothing, horses, often their most prized possessions; it was important to them that everyone had enough of what was needed to live. The white man's obsession with the accumulation of material goods puzzled them and prompted this all-too-accurate remark from Sitting Bull, famed war leader of the Sioux: "The white man knows how to make everything, but he does not know how to distribute it."⁴

The Indians' way with words surely stems from their exclusively oral tradition—a tradition difficult to grasp these days when so much is written and so little remembered. They had no written language until the white man came along and told them they needed one. Many were eloquent speakers—the likes of Chief Seattle, Chief Joseph, Chief Luther Standing Bear, and, of course, Black Elk. Others were merely blunt. Washakie, a chief of the Shoshone tribe, grew impatient while listening to white bureaucrats speak at length of turning his people into farmers. He abruptly terminated the discussion with this outburst: "God damn a potato!"⁵

That was in 1887, by which time the acculturation of these proud people was well underway in all parts of the country under the arrogant banner of Manifest Destiny. The symbolic final blows in the subjugation of the American Indian came in 1890 with the murder of Sitting Bull, the end of the Ghost Dance (a nonviolent religion totally misunderstood by the whites), and the massacre of several hundred Sioux men, women, and children at Wounded Knee Creek, South Dakota. Black Elk, who survived the ordeal, recalled the horror of that incident with gut-wrenching finality:

And so it was all over. I did not know then how much was ended. When I look back now from this high hill of my old age, I can still see the butchered women and children lying heaped and scattered all along the crooked gulch as plain as when I saw

them with eyes still young. And I can see that something else died there in the bloody mud, and was buried in the blizzard. A people's dream died there. It was a beautiful dream . . . the nation's hoop is broken and scattered. There is no center any longer, and the sacred tree is dead.[6]

Such was the attitude of hopelessness among Native Americans some one hundred years ago. A people who for centuries had ranged freely over their own vast country were now confined to tiny fractions of that space. Their horses and guns were taken from them, ending the nearly full-time activity of hunting and processing food. In addition to being coerced into dressing and acting like their white conquerors, Indians were denied most of their traditional religious ceremonies, including the Sun Dance, a rite of renewal and purification practiced by many of the Plains tribes. In short, they became a people with a great deal of time on their hands—time that came to be used more than ever in the making of what we call their art.

By the turn of the century, collecting Indian art had become extremely popular, especially with people who had access to the reservations. One such collector was David T. Vernon, who developed a keen interest in the Plains tribes while working as a cowboy in Wyoming and Montana. Besides being a wrangler, Vernon was a commercial illustrator. But he became best known for his skill as a collector of Indian paraphernalia, a talent he put to use for many important museums. In the process, Vernon acquired a sizable collection that he eventually

sold to the Jackson Hole Preserve, Inc., a conservation foundation backed by the Rockefeller family.

In 1967 Laurance S. Rockefeller, president of the Preserve, offered to lend the Vernon collection to the National Park Service with the proviso that it be exhibited in Wyoming's Grand Teton National Park. Planning for a facility to house the collection began that year and the Colter Bay Indian Arts Museum was opened in 1972. On exhibit are 774 items representing more than 75 North American tribes, although the bulk of the 1,444-piece collection comes from the people of the Great Plains. As collections go, it is not one of the largest but it is clearly among the finest.

Many books have been written about collections of Native American art, most of them from a non-Indian point of view. This book seemed to call for a different approach because as the author explains, *"Too often, this art becomes separated from the unique environment that influenced its creation and development. Taken out of the tribal context and interpreted solely in terms of the dominant society's understanding of it, the most important perspective of all is conspicuously absent."*

▲▲▲▲▲

In this statement, Anna Walters gives us a glimpse of Indianness—a *knowing* that stems from her tribal roots on the Oklahoma Plains. Her heritage is Pawnee and Otoe-Missouria, and her special gift is storytelling. She has chosen to introduce us to elements of American Indian mysticism through a series of "spirit voices." Springing from dreams and visions into written form,

19

these unearthly voices seem to breathe life into objects of unusual, often mysterious, beauty. In other sections of the text, Mrs. Walters reverts to a conventional writing style to give us more down-to-earth data on portions of the collection.

When looking at some of these items in a museum setting, there is a tendency to view them as curiosities created by people who no longer exist. Such thinking is in error. Just as there is more to Indian art than meets the eye, there is more to the many Native American cultures than most of us realize. There is a resurgence of interest in and respect for the traditional ways. These are living cultures, not dead ones. And we might do well to heed the poignant words of Chief Seattle, a leader of the Suquamish tribe, in a statement to Isaac Stevens, governor of the Washington territory, in 1854:

When the last Red Man shall have perished, and the memory of my tribe shall have become a myth among the White Man, these shores will swarm with the invisible dead of my tribe, and when your children's children think themselves alone in the field, the store, the shop, or in the silence of the pathless woods, they will not be alone. . . . At night, when the streets of your cities and villages are silent and you think them deserted, they will throng with the returning hosts that once filled them and still love this beautiful land. The White Man will never be alone. Let him be just and kindly with my people, for the dead are not powerless. Dead, did I say? There is no death, only a change of worlds.[7]

TOM CHAPMAN, EDITOR

When the first Europeans reached the shores of this continent nearly five hundred years ago, it was a vast, fertile land that supported millions of culturally distinct people who spoke in hundreds of different languages. Although no one knows for sure, a few experts believe as many as one hundred million people were then native to North America. More conservative estimates make it between six and sixty million. While it is true that many "Indians" were killed defending their sacred homelands, warfare was not the principal cause of their demise. Some demographers estimate that as many as nineteen out of twenty Native Americans died of European diseases like smallpox, influenza, and tuberculosis. The "Trail of Tears"—the infamous forced march that decimated the Cherokee nation—was followed by a trail of broken treaties. Today, Indian-owned lands comprise only about two percent of the contiguous forty-eight states.

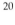

ARCTIC

ARCTIC

SUBARCTIC

SUBARCTIC

NORTHWEST COAST

PLATEAU

CALIFORNIA

GREAT
BASIN

GREAT

PLAINS

NORTHEAST

SOUTHWEST

SOUTHEAST

Petroglyphs, Petrified Forest, Arizona (photograph by Willard Clay).

THE SPIRIT SEEKERS

23

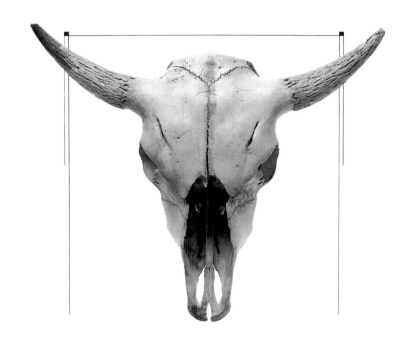

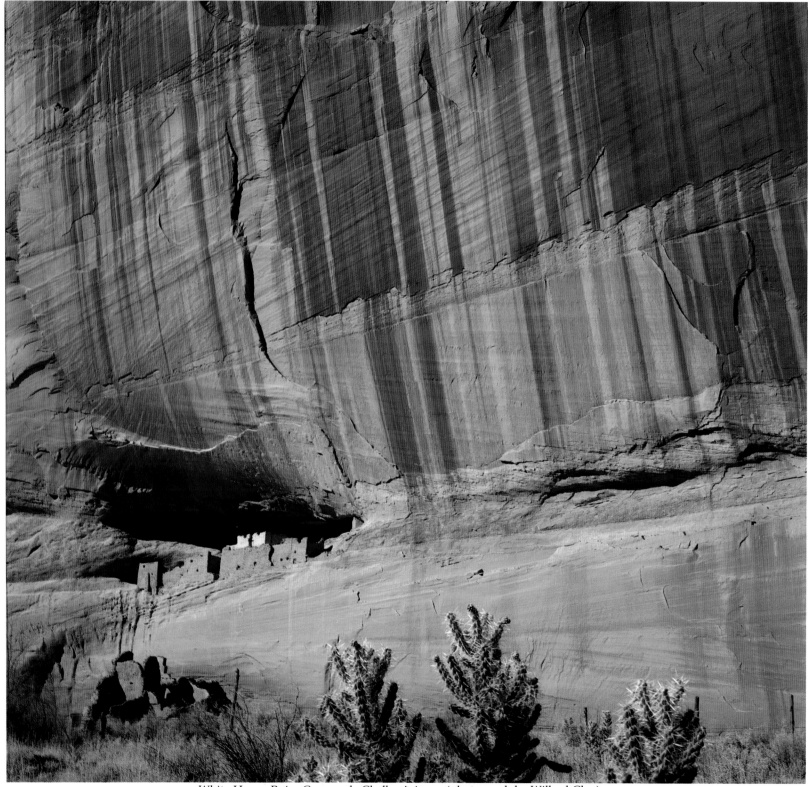

24

White House Ruin, Canyon de Chelly, Arizona (photograph by Willard Clay).

C all me Spirit Seeker! For dreams are always with me. As pulsating crystal stars on glassy obsidian nights, dreams guide me to points I must reach, spiraling inward to my deepest core or flying out beyond me to powerful living spirits.

Dreams are my power, the unseen spiritual essence of my soul given substance and made tangible. Through them, healing is possible and earthbound souls may soar! They are voices singing in unison, celebrating the dance of life within me and far across the galaxy. Born independently of all my mortal limitations, dreams make me whole, restoring each missing or broken part of me. Then they eloquently speak when my own words are frozen by fear or indecision.

Is it any wonder that dreams, visions, and traditional knowledge are the deep wells from which I draw to reproduce ancient images of the universe, of spiritual beings, and of the great mystical cosmos? I cannot stop myself from fashioning images, for as I dream, I live.

The images created by my hands are echoes of the dream-voice within me. They are also evidence of my dream-power, because some of my images can be magic used to heal or destroy, though by vocation I am no sorcerer. The images are

powerful by virtue of the forces they represent or by what material and means they came into being.

I put a bit of myself into them—my view of the cosmos into a basket, my fingerprint upon a pipe bowl— though you cannot see it. You may simply see isolated, inanimate objects, separated from the spiritual context that inspired their creation. You do not know that I borrowed colors, forms, and materials from a living universe, or that I focused on one haunting image of my dreams and, talking to the image as I worked, it took three-dimensional shape, crawling out of my dreams and the spiritual realm of the universe by its own animal power! The mouth of the carved image opened slowly and spoke; it laughed and sang! Its sculptured legs bent and dashed across the smooth pipe stem. So the ancient, enduring dream-images escaping from my hands are not mine alone to hide and hoard. Living spirits that they are, these things transcend single lifetimes and countless generations of spirit seekers. Such powerful images live lives of their own as I live according to dreams. By this knowledge, I am enriched and for this enrichment, my soul dreams.

Call me Spirit Seeker! For I was born into sacred nations that say the world is alive with animated spirits waiting to show themselves to us in sacred moments. They bring spiritual enlightenment to the darkest recesses of even the most rational and disbelieving mind.

The nations are old, themselves children of supernatural flow, marked by symbols of totemic blood or magical ties to spiritual origins. Tribes, bands, and clans were wondrously conceived in their own cosmologies. They were born in the halo of the sun, misty silhouettes that scattered to the winds over this sacred land. Soon their presence was known in the mountains and woodlands, on the plains and plateau, across the desert, down to the gulf, and along each coast.

This is how it was at *the beginning*—the beginning being not so much a point in time as a holy place in the minds of olden nations. Each spiritual birthplace is the center of the world. And the center is a power source in many spiritual landscapes. The real legacy of spirit seekers is the journey to the spiritual zone, not material goods or possessions.

In the course of their existence, the nations were frugal. Spirit seekers and the entire spiritual realm were fully considered before anything was taken into the nations' cultural store. Access to animated spirits and the universe was more valued than any material thing. The few possessions individuals owned were mainly for survival and spiritual access.

Look here at archaic bones and find stone points of the nations' ancient hunters! Lichen-covered boulders hide prehistoric pictographs. An abandoned cave with a black-smoked star-ceiling protects robes of rabbit skin and bluebird feathers. Smooth alabaster banner stones and grinding tools wait near swollen mounds, while great pueblos and golden cliff houses promise more than silence and lead on to stone tipi rings, and . . .

I had a hand in each of these images you see. My presence will be found on every visible human-made

26

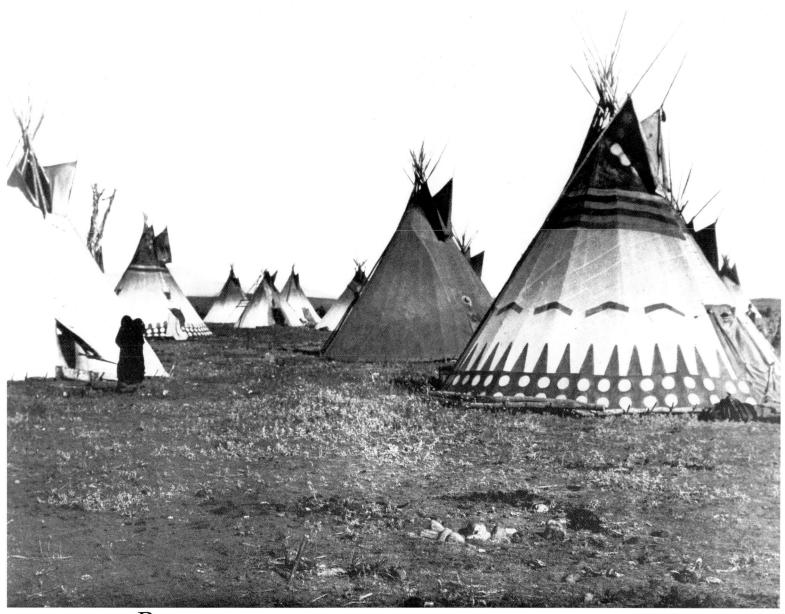

Piegan Tipis, 1900 (photograph by Edward S. Curtis, courtesy of the San Diego Museum of Man).

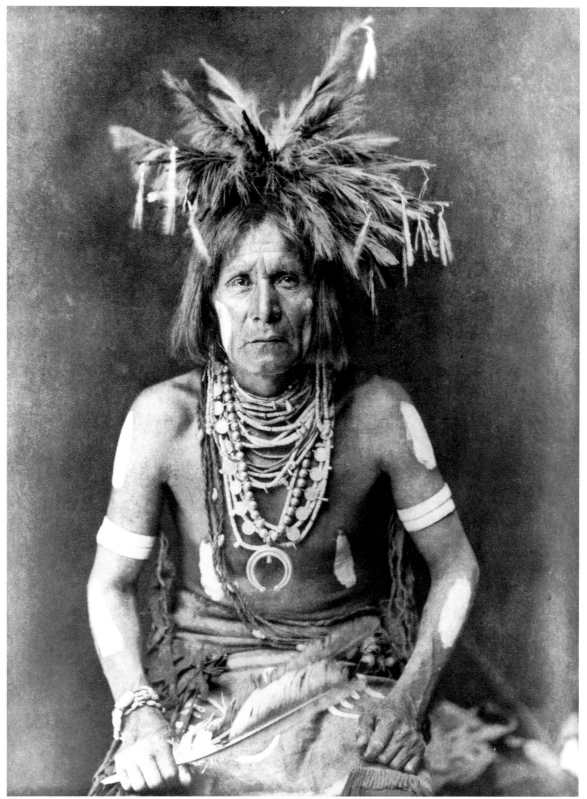

Hopi Snake Priest, 1900
(photograph by Edward S.
Curtis, courtesy of the
San Diego Museum
of Man).

tool, object, item of apparel, and dwelling that might be hidden in the surface of this sacred land.

I shaped the arrowheads that were flung afar. I saw majestic animals dip and fall from the power of the stone points, giving themselves to the nations. The beautiful stilled eyes of the animal people turned cold and looked off into the next world, but their spirits hovered close by to hear the nations give thanks to them.

It was I who carved the scene into the rock and painted it on a cave wall. Images of thundering bison, moose, elk, and deer. For their bodies fed and clothed me, and their spirits touched me, and I was led by dreams. To put on hides of wolves and buffalo is to feel these spirits stir within me. Then our spirits join and I am transformed! Shadowy places in my mind and in the universe fill with light. In this I see that all life is really one magnificent spirit flowing through all the forms around me. There is a vast spiritual realm beyond what is seen. This is what the nations have always known through spiritual blood, traditional knowledge, visions, and dreams.

Call me Spirit Seeker! For I see more of the universe than meets the eye. I perceive an infinite holy person, endowed with a life force that flows unceasingly as a liquid rainbow into every sacred part of the being.

Other personages exist within the crystalline form and I see them clearly as holy persons too. I see them in the dawn, in the sun, in the moon and stars. They are in the wind, in the rain, in the fog, and in the clouds. They live in the earth, in fire, in the air, and in water.

These holy beings enchant me by their appearance, their presence, their longevity. That they exist both in physical and spiritual dimensions apart from me, yet of the same force flowing within the cosmos, opens up my mind. And I perceive beauty.

Having been born into the nations, I know with profound certainty that infinite life *is* beauty. This is the call I hear chanted throughout the universe. The birds sing it and the animals recognize it. Everything the eye can see is in accord with it.

It is not within my power to create anything more significant than this sweeping, endless harmony reverberating through the holy beings in existence out there. Still, I am of the nations and my nature is to celebrate the harmony that they have adapted into their prayers, their songs, their dances, and their ceremonies. This participation opens my mind, a breeze sails through me . . .

Then I come face to face with beauty, the translucent spirit that flows unceasingly through the earth and up to the clouds and stars. When my reverie ends, I hold pieces of work I have created that depict members of a cosmic spiritual family, a rainbow of figures stepping from shadow into light. Side by side, all the pieces speak for themselves of animated life, the dreams and visions that call and pursue spirit seekers. Each figure is unique, though its form may follow an ancient pattern. And each figure is a reflection of spiritual thought, even the roughest image.

Through everything that I have created since I was born, my life, my dreams, my physical and spiritual

being are now laid before you. Through these things you can know how the nations live and you may even glimpse the spiritual world I was born to see!

Call me Spirit Seeker! For I am no longer entirely of the tangible world. I fly out to the stars and I drift on the fog and clouds. Time has no meaning for me except to define the beginning of the nations and the center of the world. I follow a mystical path without time that I was set upon thousands of years ago. It is a path of holy people who might be seen in the dawn, in the sun, in the moon, and in the stars.

My link to the tangible world is through the continuity of the nations. As long as the nations live, so will I be with them. And as long as we exist, I will dream—of ancient images, of spiritual beings, and of the great mystical cosmos. Spirits I will seek.

Unless you are aware of the nations, knowledge of spirit seekers in the tangible world will begin with the things you see here. They speak of me, spirit seeker that I am, and the spiritual nature in everything that lives— the visible and the invisible—and a relationship of universal kin. For we are all one.

These things before you also represent the nations' lives and this is why the nations cherish them. I, too, love them, for they represent the wonderful things that I have dreamed. They stand for beauty that calls to the nations and to me. And they are the receptacles for my dreams, as everything that lives is a receptacle for the translucent life force.

The nations and spirit seekers are one, born of the same spiritual blood, dreams, and visions. I am a spirit seeker, given to dreams and, awake or asleep, I dream rippling images of infinity and holy personages within each living thing. The nations are my family. Because they love spirit seekers, they open my mind and point me toward beauty to seek marvelous spirits within and outside myself. Thus I have learned that my spiritual blood runs deep; it is the source of my dreams and the essence of my iridescent soul. Even now, it is what possesses me to speak!

30

North Pueblo, Taos, New Mexico, 1925 (photograph by Edward S. Curtis, courtesy of the San Diego Museum of Man).

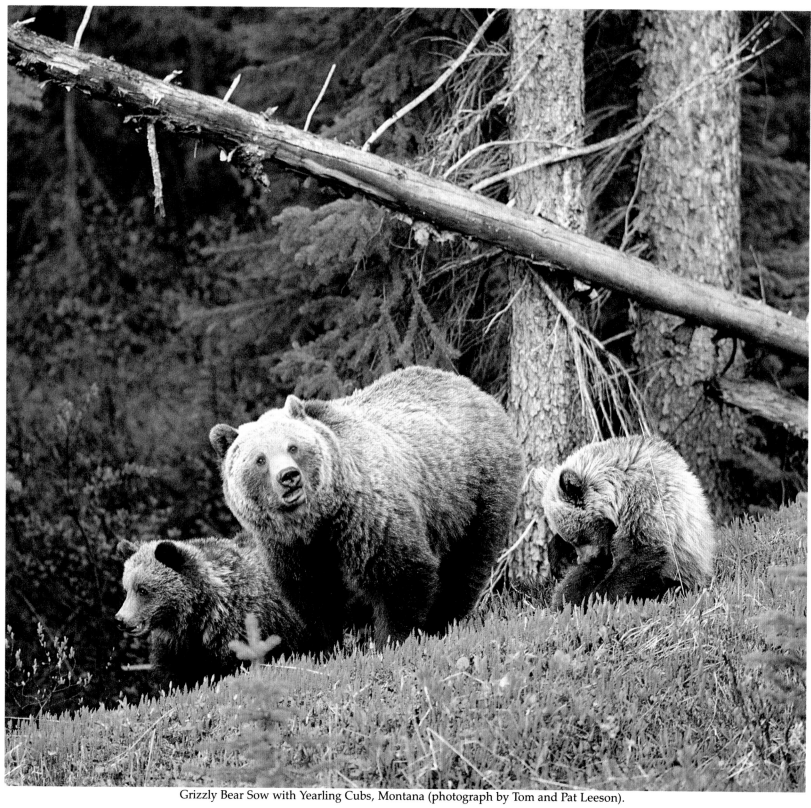
Grizzly Bear Sow with Yearling Cubs, Montana (photograph by Tom and Pat Leeson).

THE SPIRITUAL AND
COMMONPLACE ARE ONE

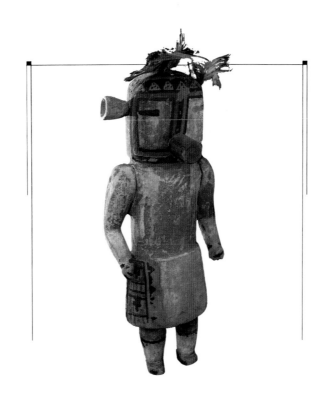

33

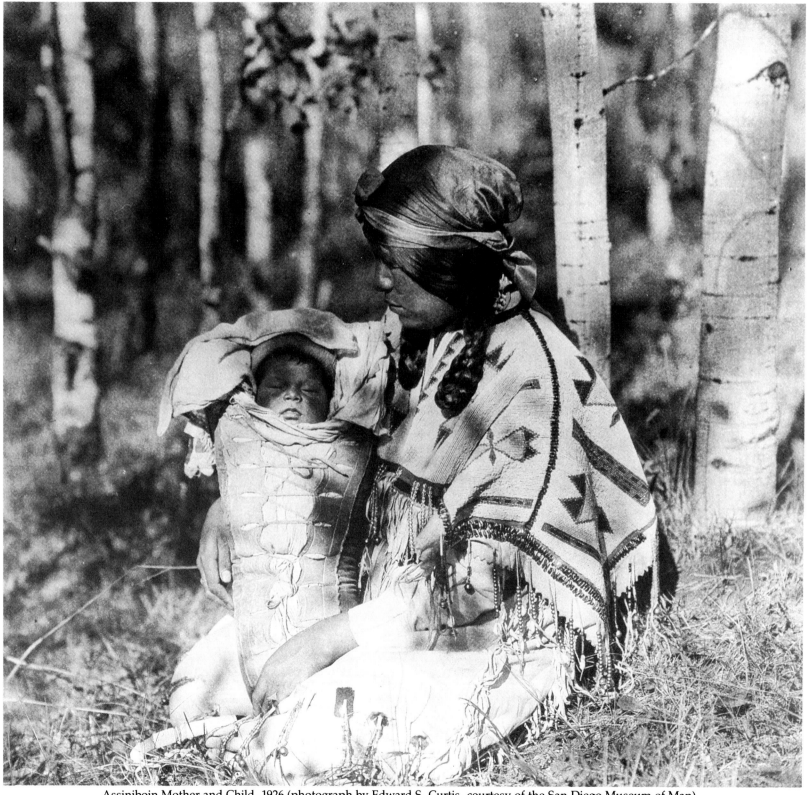

Assiniboin Mother and Child, 1926 (photograph by Edward S. Curtis, courtesy of the San Diego Museum of Man).

THE SPIRITUAL AND COMMONPLACE ARE ONE

By the nations it is said that the cosmos is wonderfully ordered. We see evidence in the change of seasons, night and day, life and death. A vital aspect of this order is the pairing of all things, without which infinite life would not continue. In this pairing, the power and presence of the female element is an essential companion to the male. They unite to make the cosmos whole, a place of continual regeneration and vibrant beauty, a wondrous inner realm that gives form and substance to the material world. This mix of the spiritual and commonplace is experienced by the nations as the essence of daily life. But listen! Coming from within is a female voice, deeply resonant and surprisingly strong . . .

Do you hear it now? My voice calling in the wind? My voice under the children's high-pitched cries? My voice entwined with the men's? My voice rising in song? My voice whispering in prayer? My laughter bursting forth after the inevitable tears? Do you hear it now?

But, who am I, you ask . . . who am I?

A daughter of the nations first of all! Next, a clanswoman of the bear and wolf. Then a mother running after a fawnlike child, and a woman mature in the ways of olden nations.

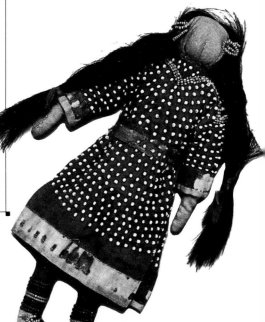

Finally, a settled elder with a den of cubs and pups to surround her. This is who I am!

My mother called me to her before I was born! She searched for me in her dreams and prayed to spirits that her call would be heard. After I was conceived, lying curled in her belly, the older women came forth to sit at my mother's side. Learned in child-rearing, they advised her about the nations' children—ancient knowledge and taboos to keep the cycle going. My mother listened, taking to heart everything they said and did, because it was for her and for me that the nations lived! So I was given life, an iridescent rush first in her mind and heart, and later, her child was born!

One of my grandmothers helped me into this physical world. She cut my umbilical cord and took it away according to custom and wiped my face and body until my skin was rosy and warm. I kicked and then my arms moved on their own. She laughed, a chuckle for each surviving newborn. My tiny hand caught and clutched firmly at her finger. At that moment, my instruction began on what it meant to enter the circle of these dwellings and to be one with the nations.

As an infant, I was given a name by which I would be forever known to the cosmos. Then they put moccasins on my feet to symbolize the path I would follow in this physical world. Afterward, I was lifted up and introduced to the dawn. My first view of this world was from my mother's back as she carried me about, laced onto a board. It was a world of women that I first saw and knew as they gathered and prepared food and made wonder-

ful things for our dwellings and for each of us to wear.

I remember hands, soft and warm, reaching for me, tracing my face and belly. I remember hands feeding me from wooden bowls and buffalo-horn spoons. I remember women's voices, lullabies crooned softly into my ears and laughter that fell into each woman's lap as she cared for the nations . . . I remember dancing black eyes staring into mine, opening wide in gleeful surprise whenever I accomplished anything on my own; eyes that spoke to me more eloquently than words of who I am—a daughter of the ancient nations.

My childhood playmates were both children and the elderly. The children had miniature things from the larger world, bows and arrows to fit into boys' dusty hands and dolls for the girls. The elders, past the age of caring how they appeared to all except the youngest of us, made time to take children in their arms and to act like clowns so we would laugh. They understood more than anyone the spiritual renewal that young life brings.

Seasons passed and I grew into a young girl. I helped my mother and the other women gather and prepare food. I was entrusted with the smallest children. The elders, too, asked for my help and it pleased me to do things for them, such as cooking and carrying water.

One day my mother and grandmother told me that I would soon have my own dwelling. I expected it after that for they had given me the most truthful facts. I waited and prepared. Then a young man's family came for me and I left my mother and father's dwelling. I went with my new family as it had been foretold. By then I

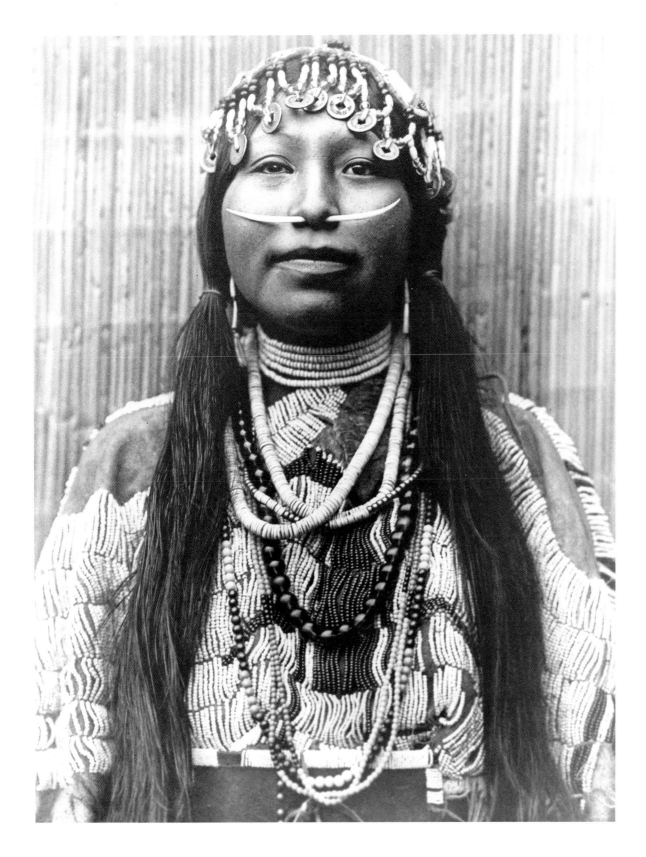

Girl of Wisham Tribe, 1910 (photograph by Edward S. Curtis, courtesy of the San Diego Museum of Man).

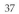

38

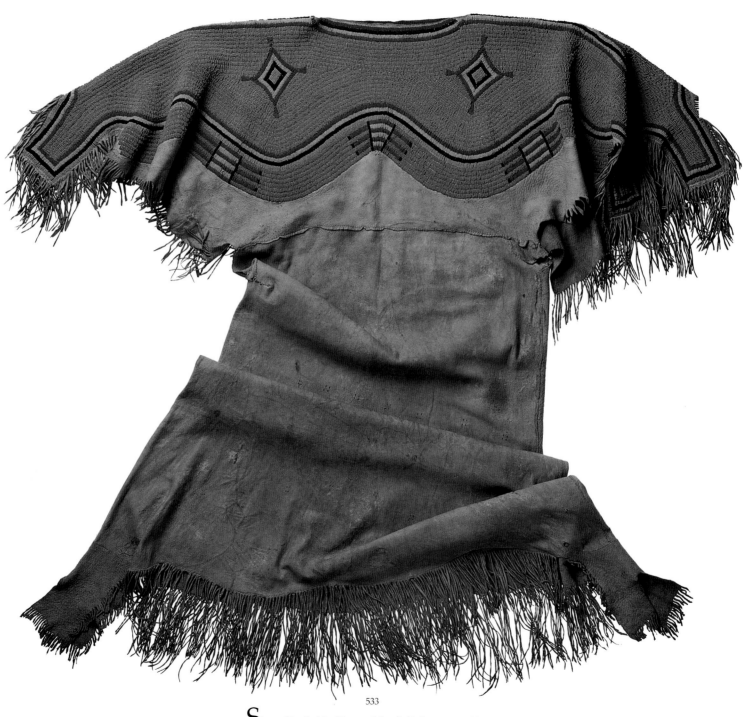

533
Sioux Buckskin Dress, North Dakota, ca. 1885.

was sixteen years and my husband was four years older.

It was a glorious time for that young man and me! We lived simply by the hunt, but in the beautiful way of the nations. For the first time then, I really understood what life was to the nations and to me. It was the dawn lighting up the eastern sky, and it was the stir of motion rippling through the cosmos in the darkest night! It was the structure and the shelter of our dwellings. It was what subsistence the Earth Mother gave to us. It was the songs sung in ancient tongues reverberating through the cosmos. It was all this and more; and the young man I married was part of it, too.

After a time, I had children who favored their father. As they toddled about, I made robes and clothing for them and for their father and myself. When these were done, I made pottery and baskets. My hands were always busy, never tiring of following the lifeway of the nations. My children grew and left for lives of their own, and one day when I looked up from my work, I realized that many seasons had passed.

I visited my old parents to tell them of time, like water, so swiftly running. My father nodded his head and smoked tobacco; the puffs of smoke took his words up to the clear sky. Matter-of-factly, he said that the great cosmic being was what would last long after our passing; and he asked if I had ever seen or felt this great holy person dance. I said yes. Then my father told me that through that vision or dream, the whole nation had been blessed. As my father sang an old song of creation in which the world was formed and the animals came into

being, my mother smiled tenderly at me across the fire of this solid world, across the circle of the dwelling.

My life was long enough! To taste the sweetness of my infants' breath and to carry them upon my back was why I lived. When it came time to leave the physical world for that of the iridescent spiritual one, I had been taught too well to mourn my loss of it. I had lived to the fullest extent as part of a sacred cosmic family, as part of the crystalline flow going down through the ages. I had lived to see great-grandchildren lifted up and introduced to the dawn! I had lived long enough to call all the nations' children my own! I had lived long enough to see this sacred land with the farsighted vision of the nations!

And now I know that existence has no end and that my spiritual self has always lived. So consider it when you hear my voice in the wind and touch the things I have made. Everything here was done for love—of children, of ancient nations, and of the great cosmic being who fills the universe and makes us live!

Think not of indigenous cultures and nations all dead and gone from this sacred land. The physical world is not at all silent or what it seems. The nations live! My spirit lives! The spiritual world is everywhere! If you listen, you will hear. There are so many ancient voices shouting from this sacred land. In the distance, I hear one of a thousand songs of an ancient spiritual man . . .

Mosquito Hawk,
Assiniboin, 1908
(photograph by Edward S.
Curtis, courtesy of the
San Diego Museum
of Man).

My voice is raspy from having kept silent in so many seasons passing. In life, I experienced them as brilliant hues of colors mysteriously spinning past, as a counterclockwise-moving circle of sounds and scents pulling me into it. I saw the seasons as migratory birds leaving and returning, then as campfires always glowing, continuously stirred into flames and put out, and then as empty tobacco pouches being filled again.

For me, each season brought a song to my lips and I shook a buffalo-hide rattle to the rhythm of each! What did I sing, what did all the nations sing, but of a great mysterious spirit who lives and manifests itself in the rainbow wheel of seasons that forever spins? Truth being what it is, my songs are variations of the songs of other tribal men and even of the women. For we are all of one mind and thought about the cosmic nature of things.

Looking back now to my own experience in the physical world, it is a vivid dream never gone from my spiritual self or this sacred land. That I was born into the nations was quite a wonderful thing and through this deep association, I was kin to the earth and sky. Though you know me not and may even doubt my presence in the past as well as now, I tell you that I was always here. The Earth Mother knows her child, my hands tugging at the soil for herbs, food, and shelter. The Sky Father knows the faces of his children, looking upward to address the spirit people in the wind, in the rain, in the fog, and in the clouds. Ah, I loved this physical world dearly. And I loved life passionately. I fought for it, you see.

Against the enemies of the clans, bands, and nations, I took a bold stand. At times, my hands held weapons to defend myself and the nations when they called! So I knew well the ways of war. It came with life, it came with being part of the nations and wanting to live. And my story is about this alone—the sacred desire of all beings to live, to flow down through the iridescent river of time.

It happened that I was born in the fall, when the great herds were fat and plentiful. The band was on a major hunt and my mother did not accompany it. In the excitement of the hunters' return, my mother gave birth to me. I wanted to be born! I came too late to go on that hunt and that was the way the clans and band knew me. In my lifetime, I used many names to mark my personal and spiritual growth and to identify myself for the nations and cosmos. Names were never given lightly, being such powerful things.

When I was released from my cradleboard, I took off running! My childhood was spent running errands for the women, for my father, and for the old men. But there was always time for play when my father dunked me in water or rolled me in deep snow. I followed after him when he allowed it.

By the time I was so high, I knew a good deal about this physical world. I knew which animals were favored for food and how the animal spirits were appeased. I knew most of the stars by name and had learned to ask them to take me safely home. I knew which things in this physical world might be harmful if I gave myself over to them.

41

Exactly when I became conscious of the world's spirituality, I do not know. Perhaps it was there on the day I was born. Perhaps it became clear through the rituals and ceremonies. But it was there. As a young child, I already knew there were playful spirits in the wind, in the lizard sitting motionlessly on my hand, and in the pups playing around our camps. I felt there was something that was unseen in me, but nevertheless was the link to everything else here.

Growing older, I followed men out onto the plains to hunt. When I was twelve, I killed my first deer. When it fell before me, its iridescent spirit was released and darted about, and my own spirit left me and ran toward it! What I remember most is not that the deer died, but that its spirit lived! That deer gave me much, its magnificent body and exuberant life! I learned to be grateful for it and to make the most of these precious things! The deerhide I gave to my mother, the first of many I was to take to her. She took it and stretched it out, scraping off the hair. It became a soft white dress for her to wear.

One memorable morning some old men called me to them. They told me of spirits in the four directions, in the earth and sky—spirits that I ought to know if I were to develop fully and be an asset to the nations! They said it was time for me to know the great cosmic force that was responsible for all our existences. My father agreed and my mother gave me up to the plan of the nations.

The old men stripped me of most everything I wore and sent me out to make contact with the great cosmic force. It seemed that I wandered for days and became lost to everything that was familiar in the tangible world. But I waited for spirits! In the surrounding silence, my thoughts went to the old men of the nations. Then I heard a flapping of heavy wings and a stately night bird flew in concentric circles above me. The blue-black night seemed to swirl its thick colors behind the sheen of flapping wings and the bird screeched at me. Its taloned feet sailed down to me. I did not move, for this was exactly what I had come to see! The silky bird now settled on the ground beside my hand and pecked at me. Once more it gave a shrill scream and flew off into the night, leaving dark feathers at my feet. That was how the rest of my life began, seasons and seasons of meeting spirits on their own ground and terms.

Another important happening in my life was marriage. The first union was in a beautiful sweet season that was too short. In my lifetime, though, I had four wives and we gave each other several children. Through my relationships with these women, I lived well and we did what we could for each other.

As a middle-aged man, life was very pleasant. Days were spent with the leaders and elders, and my own dwelling was where I slept. The women and my children cared for me and provided food, clothing, and other possessions I needed. By then it was clear to me that although the road is long and rough, it ultimately leads to the spirits in the stars. The cosmos moves in a great circle and we are carried along with it. This is what we sang in our songs, at night in my dwelling or in the great councils of the nations. When I look now at the flutes,

42

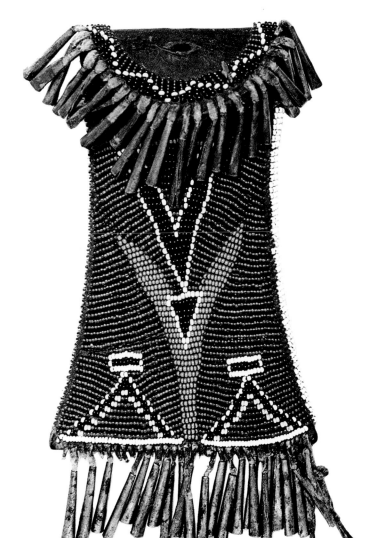

Kiowa Bag, Oklahoma, ca. 1890 (photograph by Jerry Jacka).

drums, and other things left here by our singers of long ago, I yearn to sing some of the songs that have yet to be sung again.

So that was how I lived. As one with the nations, as one with the great holy person whom we see in all the life around us!

One day my life ended, its cycle complete. But my spirit, like the spirit of that first deer I killed, was released and flew out into the spiritual world. The nations knew that my deepest self would never die, and in this way they spoke to me, to my family, and to my children, as we parted for different worlds.

Yes, I still live. I still sing ancient songs of spiritual man. What is he, after all, but his own song and spirit, after his body is given back to the Earth Mother and Sky Father? The nations and the great cosmic family know one of their own! They know who I am and where I dwell! Even now, at times, I come face to face with one of the nations. When they leave the ordinary world and go in search of ancient truths about the universe that only spirits can bring, they call out to me. In one magic moment, they reaffirm what they have always known. And my spirit cannot stop from darting out to them!

43

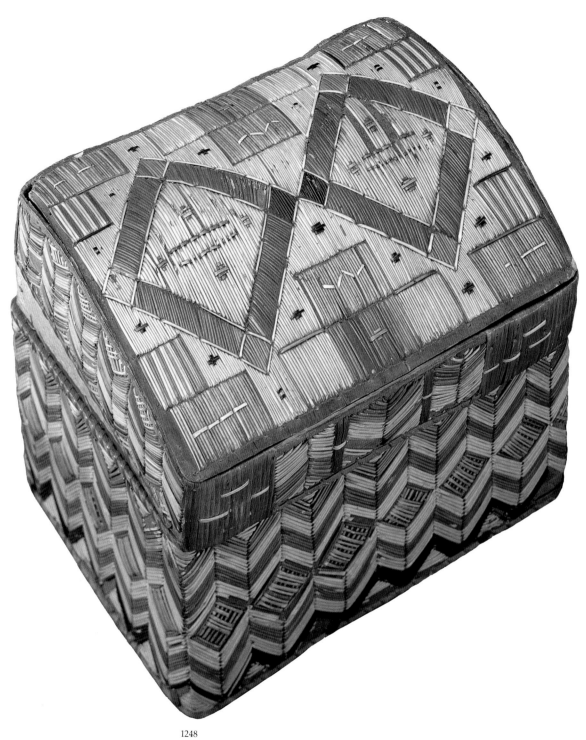

44

1248

Micmac Birch Bark Chest, Nova Scotia, Canada, ca. 1850 (photograph by Jerry Jacka).

Native American artifacts reflect a persistent belief in the natural environment as a divine source of materials, tools, and artistic inspiration. However, despite a fairly common approach to daily life, tribal societies were often diverse; their languages, dwellings, clothing, utensils, and crafts differed widely, even when tribes shared a particular environment or came into close contact with others. Some societies were quite sedentary, their tools designed to enhance life as fishermen or farmers. And even these sedentary groups were not all alike. All tribes depended on hunting to some extent. In historic times, however, many groups appeared to live exclusively by the hunt only after they had become more mobile with the introduction of the horse. All groups supplemented their diets with seeds, which they stored in bags or pouches along with herbs and medicines. These containers were made of animal hide or were woven from natural materials such as buffalo hair, feathers, reeds, and bark. Actually, weaving is an ancient art in this country, dating back several thousand years. Woven baskets were used to store and cook food, to hold water, and to carry objects; they even served as cradles and hats.

The buffalo cultures of recent history are good examples of tribal adaptation to a particular resource. The people of the Great Plains depended on the buffalo for food, clothing, tools, and fuel, virtually all necessities. In early times, the people were forced to pursue the great herds on foot. So the introduction of the horse by the Spanish had a profound effect on most tribes because they could then hunt more quickly and more efficiently. The horse also had a direct effect on the size of the tipi, the most familiar of Native American dwellings. In early days on the Plains, tipis were much smaller because it was so difficult to drag the cumbersome poles over long distances. Since horses were able to drag longer, heavier poles than dogs, the size of these dwellings naturally increased.

In prehistoric times, Native American shelters included subterranean houses, mounds, towers, cliff dwellings, and pueblos, which somewhat resembled today's multilevel apartment complexes. In historic times, lodges were built of earth, bark, willow, reeds, and straw, among other materials.

Aside from their dwellings, members of most tribes had few possessions other than necessities such as weapons and survival tools, religious objects, clothing, cooking and eating utensils, and paraphernalia for child-rearing. Inside the tipi could be found buffalo robes for sleeping, personal sacred bundles, pouches and bags to hold clothing and ceremonial attire, food, and other goods. The only object that could qualify as furniture was the backrest, a simple structure frequently made of willow. Heavy stone tools, such as mauls, grinders, hammers, and pestles, were usually not taken to a new location because replacements could easily be made there. These and other simple tools such as buffalo bone paintbrushes, bone awls or needles, and buffalo shoulderblade hoes were usually unadorned. But most everything else—clothing, cradleboards, baskets, powder horns, even spoons, ladles, and bowls—incorporated an aesthetic element. Even trade goods such as beads, knives, guns, and axes were improved on by placing them in the proper tribal perspective. From the earliest times, Native Americans maintained a unique aesthetic vision of the universe and never was the vision separated from the functional aspects of their culture.

45

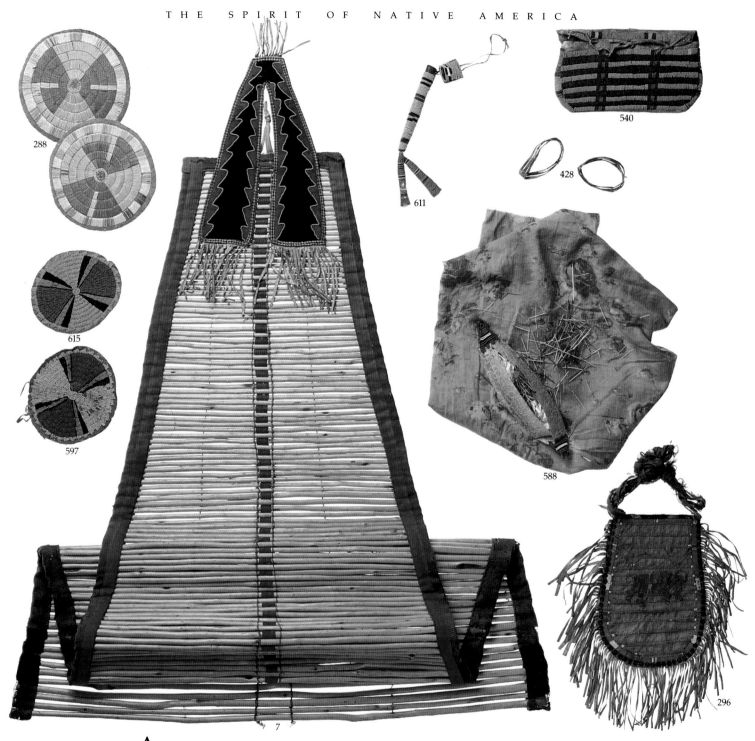

288

540

611

428

46

615

597

588

296

7

A well-furnished tipi might have contained all of the above objects, including the four gaily decorated ornaments at left as well as assorted bags and pouches. To the right of the large willow backrest on top of the piece of trade cloth is a buffalo bladder case holding a supply of dyed porcupine quills.

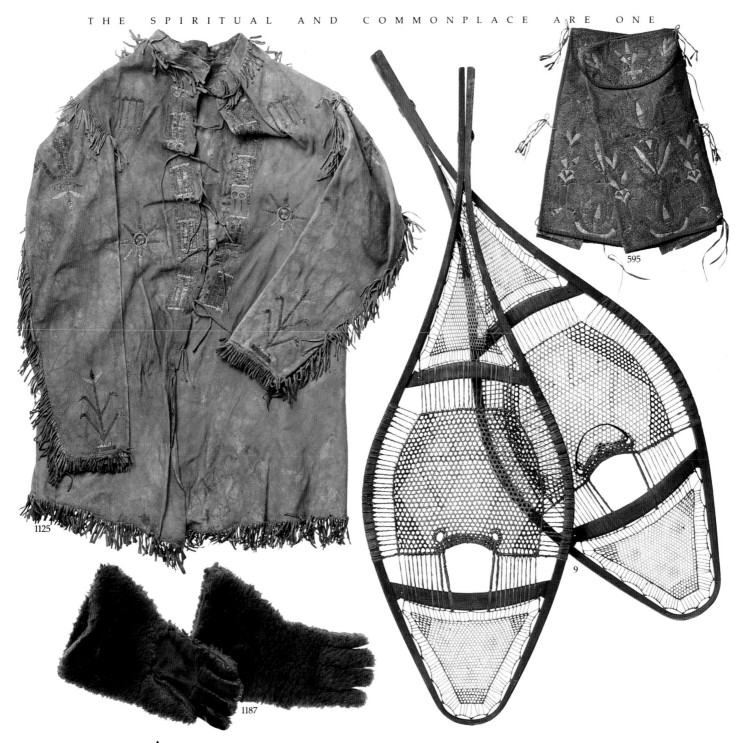

1125

595

1187

9

A Sioux squaw labored many hours to fashion this hide jacket and half leggings for her warrior husband. The heavy buffalo-hide gloves, however, were probably made by a non-Indian mountain man prior to 1874.

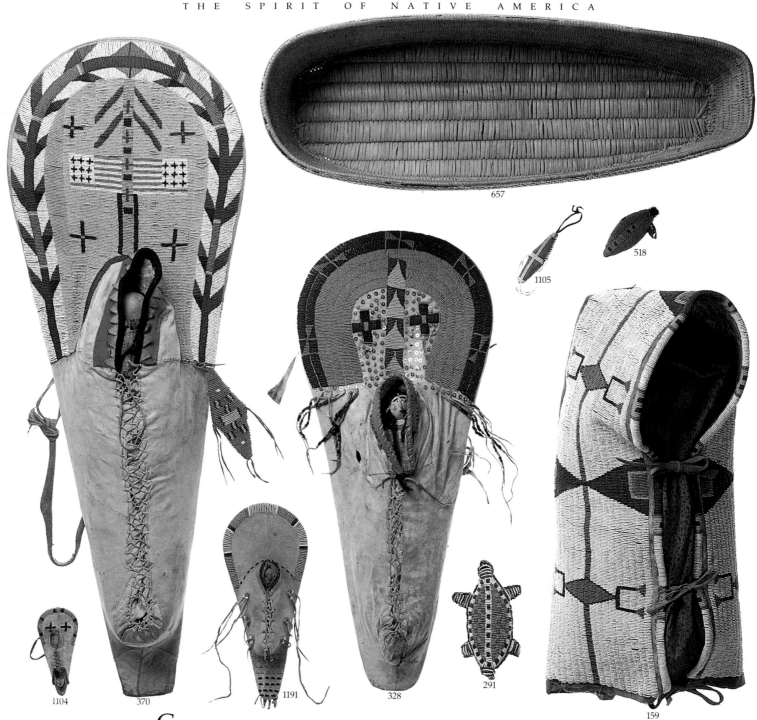

657

1105

518

48

1104 370 1191 328 291 159

Cradleboards displayed unusually high levels of detail and craftsmanship as
evidenced by the beadwork on these examples. Before trade beads were available, such
work was done with dyed porcupine quills—a much more laborious process. The turtle-
shaped pouch and the two small pouches below the basket cradle were used by Indian
mothers to preserve their infants' umbilical cords.

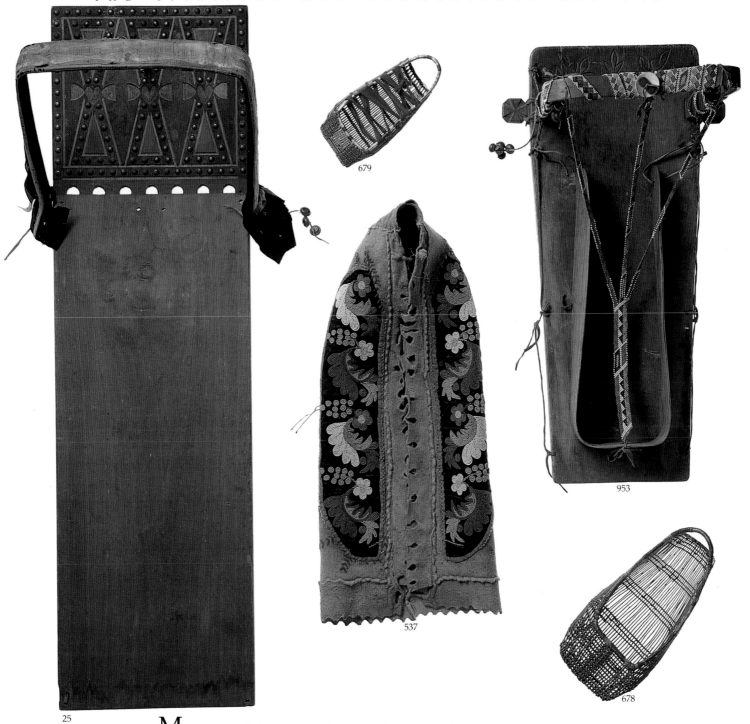

25

679

537

953

49

678

Miniature cradleboards, like the two willow versions here, were given to small girls as part of their training for motherhood. The colorful piece at center is a cradleboard cover.

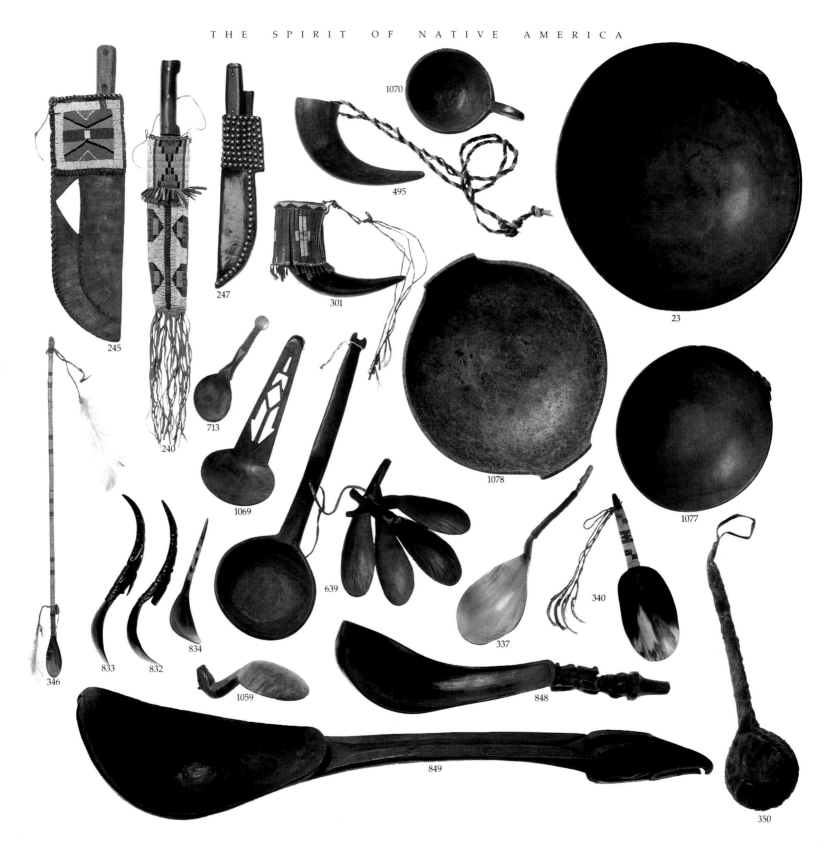

1070

495

23

1078

1077

245

50

713

240

1069

639

340

346

833 832

834

1059

337

848

849

350

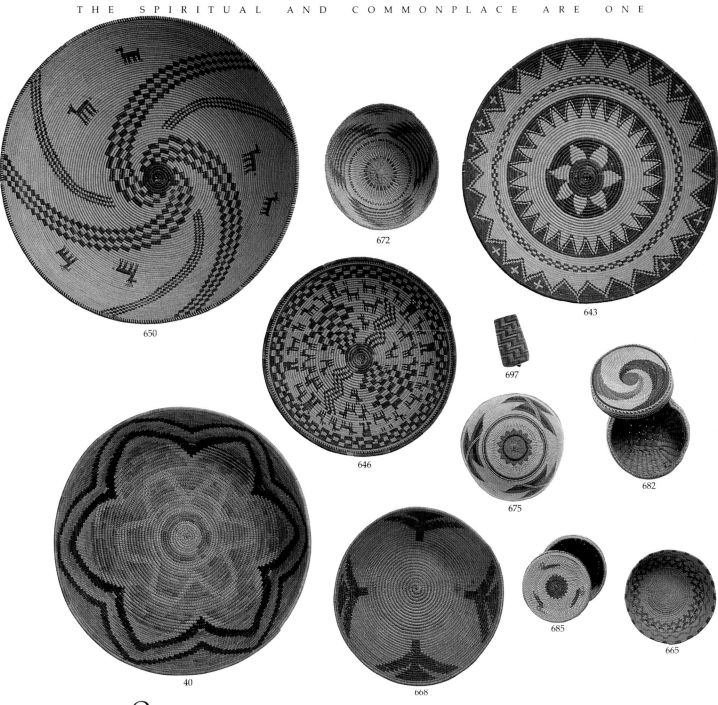

672

650

643

646

697

675

682

40

668

685

665

Opposite. The slender, arrow-shaped medicine spoon *(far left)* is the only nonutilitarian object in this diverse array of implements. Styles of embellishment varied widely as did the materials used, which included bone, buffalo horn, gourd, and wood. *Above.* The art of basketry has been a part of Native American life for more than eight thousand years. In addition to their primary use as storage containers, baskets also functioned as hats (675) and ceremonial vessels (697).

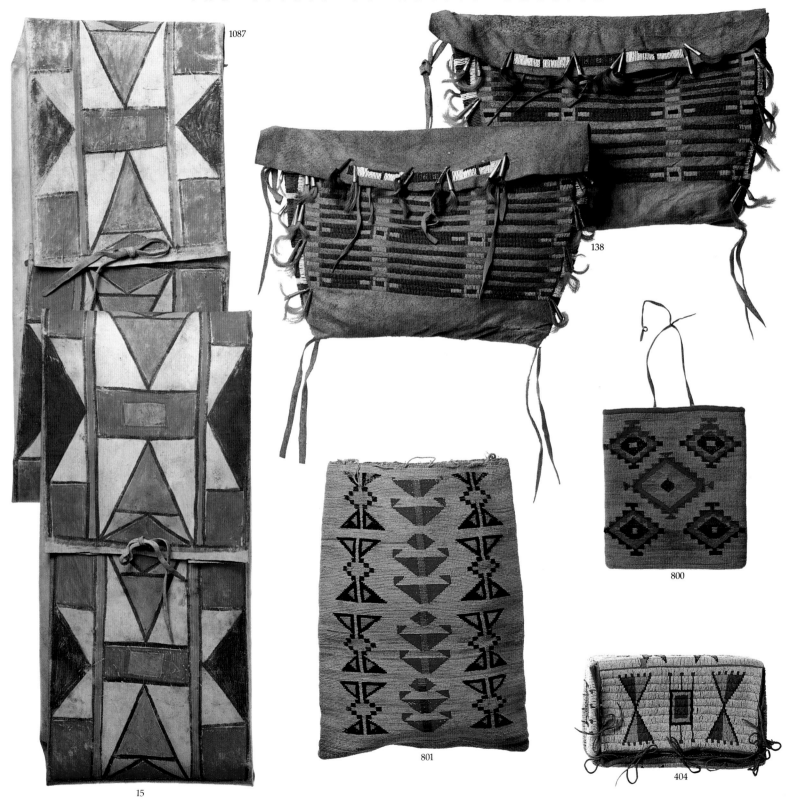

1087

138

52

800

801

15

404

27

978

*O*pposite. The colorful parfleches *(left)* are pouches made from rawhide that has been soaked in water to remove the hair. In addition to extensive beadwork, the Sioux saddlebags (138) were decorated with horsehair and bell-like tin cones, sometimes called tinklers. *Above*. The use of complex geometric designs, woven into material or painted on its surface, was common to many tribes.

54

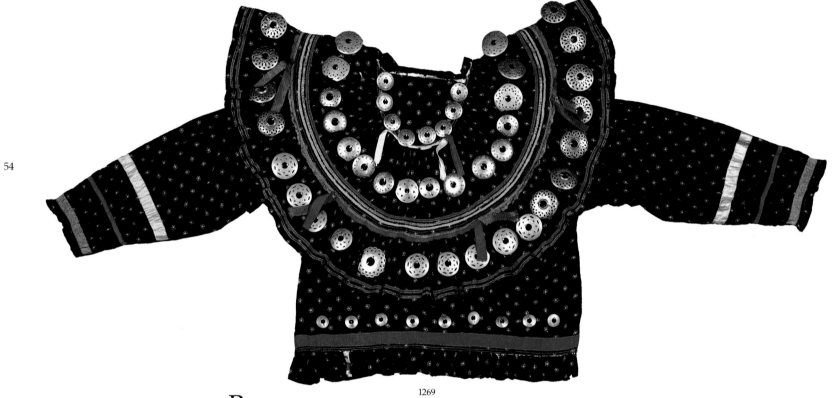

1269
Potawatomi Woman's Blouse, Kansas, ca. 1875 (photograph by Jerry Jacka).

Before the coming of the white man, clothing was fashioned from the hides of elk, moose, buffalo, mountain sheep, and antelope and was sewn with bone awls and sinew. Usually women were responsible for stretching, cleaning, and tanning the hides, although in some tribes these tasks fell to the men. Tribal beliefs dictated exactly how the hides were to be handled while garments were being made; for example, there was a precise way to fold the hides to make a dress.

Moccasins also came from animal hide, although some were later made of trade cloth. An Algonquian word, moccasin is now synonymous with all footwear of this type. Moccasins were usually not decorated in earlier times, although quill and beadwork adornment eventually became common. Late in the eighteenth century, ribbon appliqué appeared on some footwear.

In many tribes, leggings were fashionable garments for both men and women. Decorated with fringe, paint, and ribbon and sometimes attached to moccasins, men's leggings typically were cut from animal hide, while most women's leggings seen today are cloth. Strips of cloth, hide, or finger-woven yarn were tied just above the knees to hold the leggings in place. Men also wore apronlike breechcloths that were attached to the leggings.

Men's hide shirts and jackets were adorned with paint, fringe, and quillwork, and the wearers often painted symbols from their dreams on these garments.

In one form or another, beads have been used as decorative materials for many centuries. Early bead materials included shell, bone, stone, seeds, and wood. Glass beads reached this continent with the Spanish explorers late in the fifteenth century and were widely traded by fur trappers throughout the West. The large blue faceted beads, known as Russian beads, were actually manufactured in Venice, Italy. Hide dresses typically featured beadwork along with tin cones that resembled small bells, paint, and elk's teeth. Beadwork also can be seen on men's vests, armbands, blanket strips, cradle wrappers, footwear, bags and pouches, and riding gear. Sometimes beadwork was completed on a loom before being attached to an item, although usually it was applied directly. By the middle of the nineteenth century, beadwork had largely replaced dyed porcupine quillwork.

At about the same time, many tribes were adapting white-styled clothing to their own tastes. Ribbons and metal ornaments are common on shirts from this period and often represent particular groups.

A variety of sashes were made to wear as belts or head coverings. Before commercial yarn was available, early Woodlands tribes made sashes from plant fibers mixed with moose and buffalo hair. In the Southwest today, the Hopi men weave a cotton sash to be carried in a bride's bundle; later it is used by the husband in ceremonial dances. The Navajo used the sash belt in child-birthing.

Bags and pouches were used for personal adornment as well as for storage. The smallest held paint, small tools, fetishes, and other personal items. West of the Rocky Mountains, the Plateau tribes made bags out of cornhusks, a material still used today.

Jewelry, in the form of shell, bone, stone, clay, and wooden ornaments, has been common with Native American tribes since the earliest times. For the Plains tribes, materials that were extremely rare or difficult to obtain, such as seashells and bear claws, were especially valuable. Typically made into men's necklaces, bear claws were prized for their protective powers.

Late in the eighteenth century, the Mexicans introduced silversmithing to the Southwestern tribes. Early designs were borrowed from the Spanish with their heavy Moorish influence. Mexican and U.S. coins provided raw material for the early Navajo craftsmen, but both countries eventually prohibited this usage. German silver was used by the Plains tribes to make hair, belt, and blanket ornaments, and brass was often used on cradleboards.

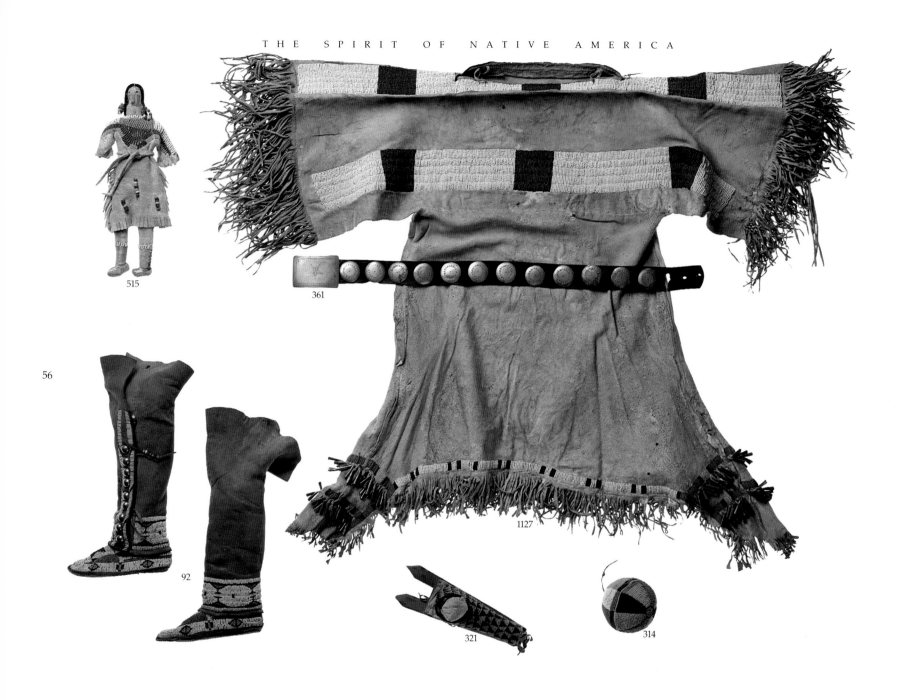

515

361

56

92

1127

321

314

A young girl of the Northern Cheyenne would have been proud of this deerskin dress with its extensive beadwork and tinklers. Although similar to the dress in decorative style, the girl's moccasins with leggings are from the Southern Cheyenne. The female doll is an example of Shoshone craftsmanship; the beaded canvas ball is Dakota Sioux.

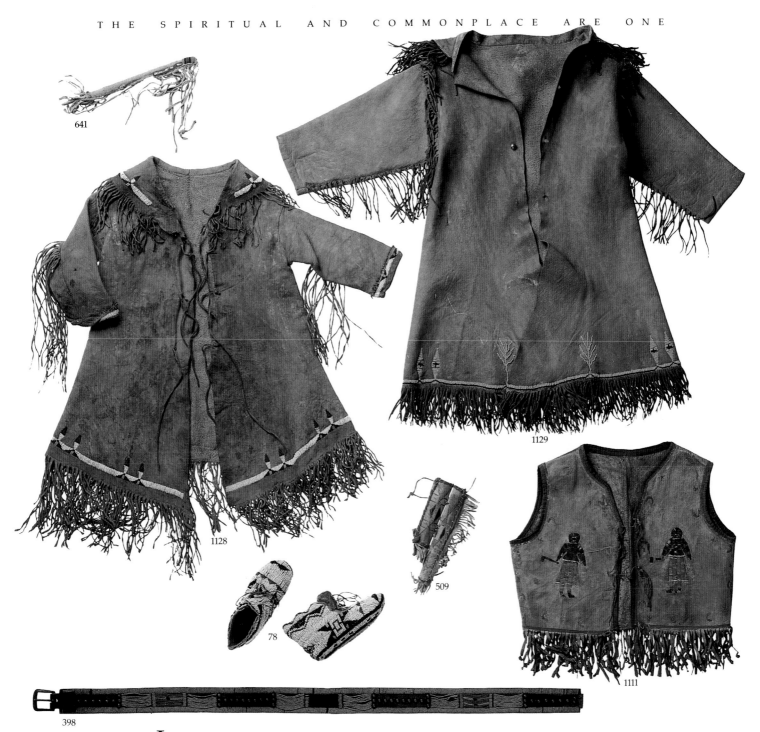

641

1129

57

1128

509

78

1111

398

Like parents everywhere, Native Americans made things for their children. Designed for instruction as well as amusement, such items were usually smaller versions of adult paraphernalia. These toys and items of clothing were made prior to 1900 for boys of various Plains tribes. The miniature bow case and quiver (509), however, were fashioned about 1920 for the tourist trade.

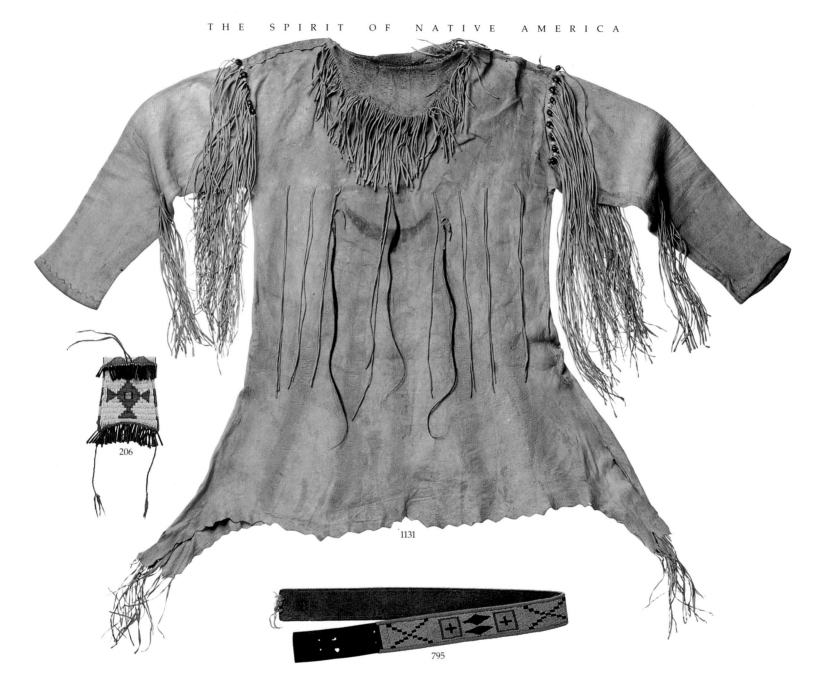

58

206

1131

795

Although collected from the Crow, the heavily fringed buckskin shirt decorated with mescal beads and human hair is actually Kiowa in origin. Purses such as the small beaded variety at left were carried by men of the Northern Arapaho. The belt is Nez Percé.

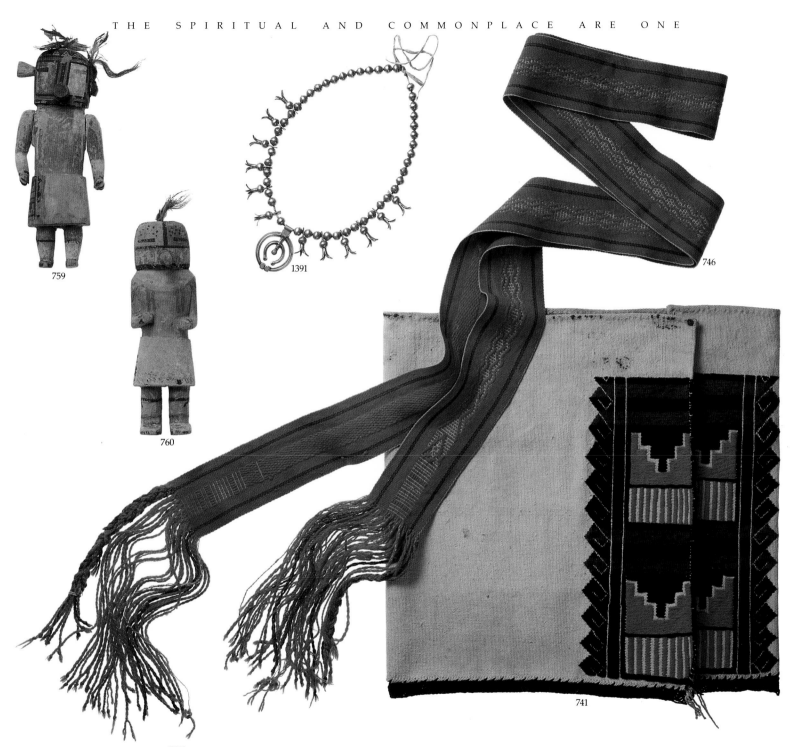

759

760

1391

746

59

741

Two Southwestern tribes are represented above. The dance kilt at lower right is Hopi as are the two Kachina dolls. The loom-woven sash belt and silver squash-blossom necklace are Navajo.

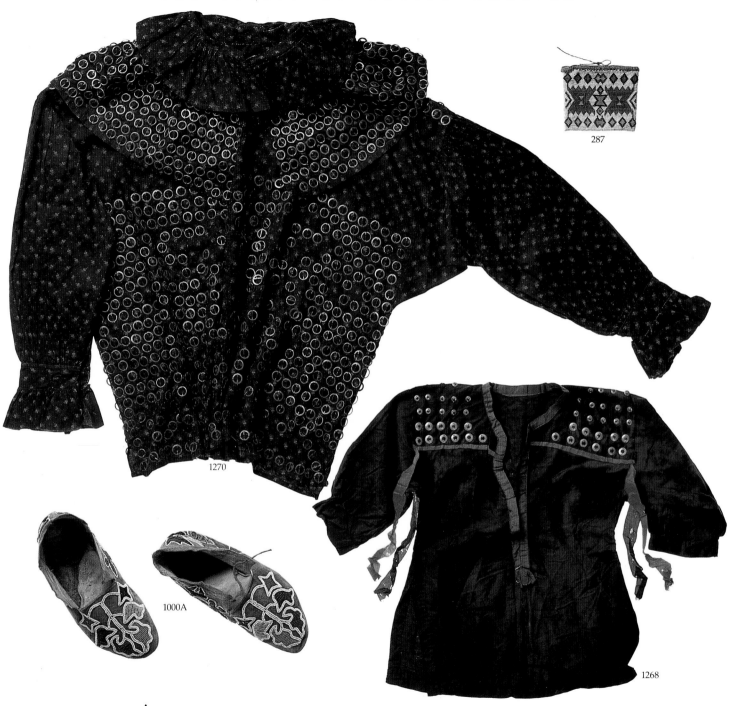

287

60

1270

1000A

1268

Although un-Indian in style, this woman's cotton blouse was collected from the Miami before 1850. It was probably hand sewn from trade cloth and is liberally adorned with German silver brooches. The child's shirt bears some of the same silver ornamentation but came from the Winnebago as did the small medicine bag. The hard-sole moccasins are Iowa, made around 1890.

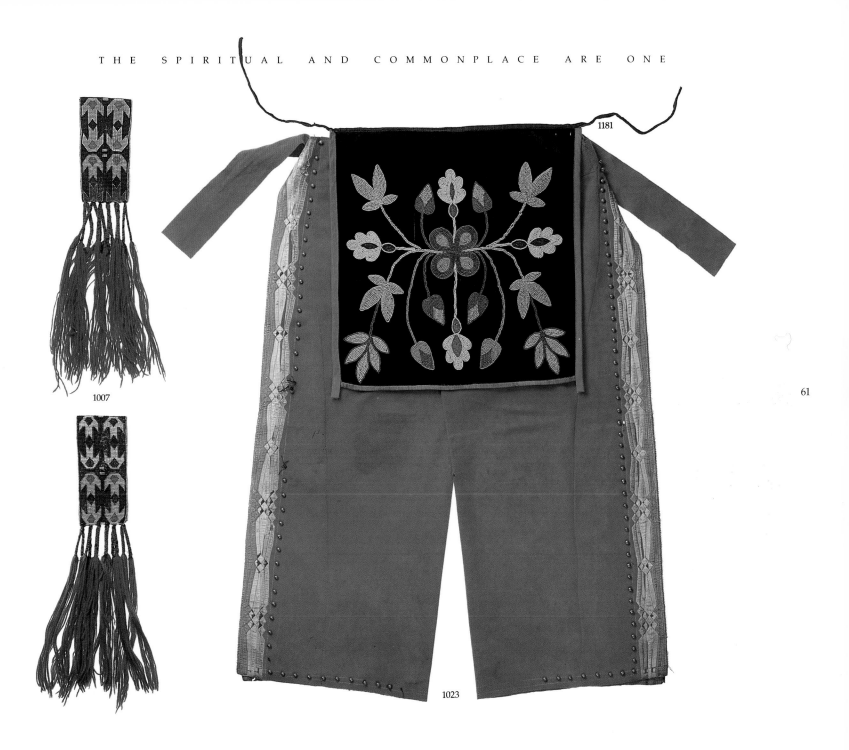

1181

1007

1023

61

D raped over a pair of Osage leggings is a heavily beaded man's apron made by the Chippewa about 1900. The purple-tasseled items at left are men's leg garters.

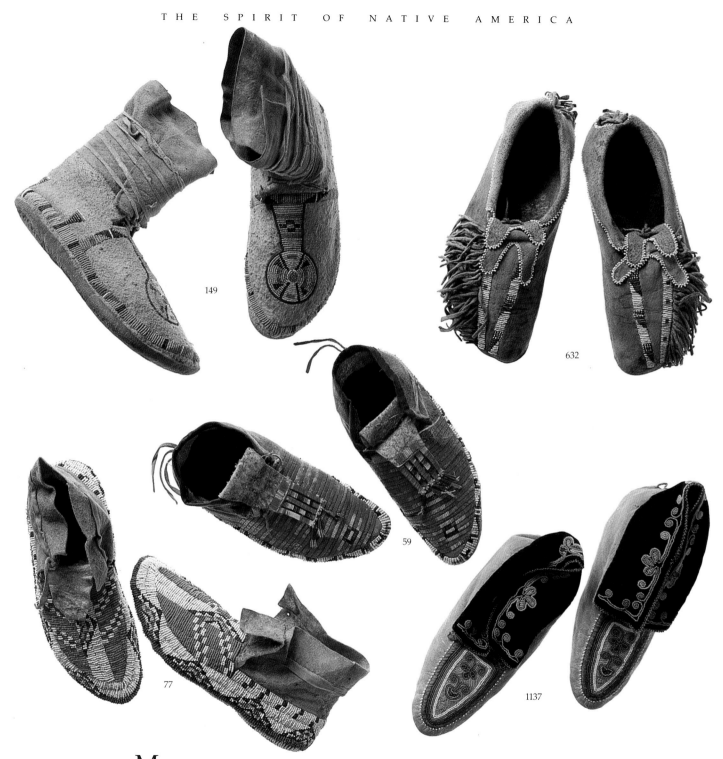

149

62

632

59

77

1137

Moccasin is an Algonquian word that has become a generic designation for virtually all Native American footwear made of buckskin. Cuffs and floral designs are typical of moccasins made by the Coastal Algonquians (1137) and other Eastern Woodlands tribes.

955

72

63

79

91

998

52

Ribbon appliqué work was popular with Southern Great Lakes tribes (998), whereas narrow beaded bands were characteristic of footwear made by people of the Southern Plains. The distinctive fringed pair is Kiowa.

64

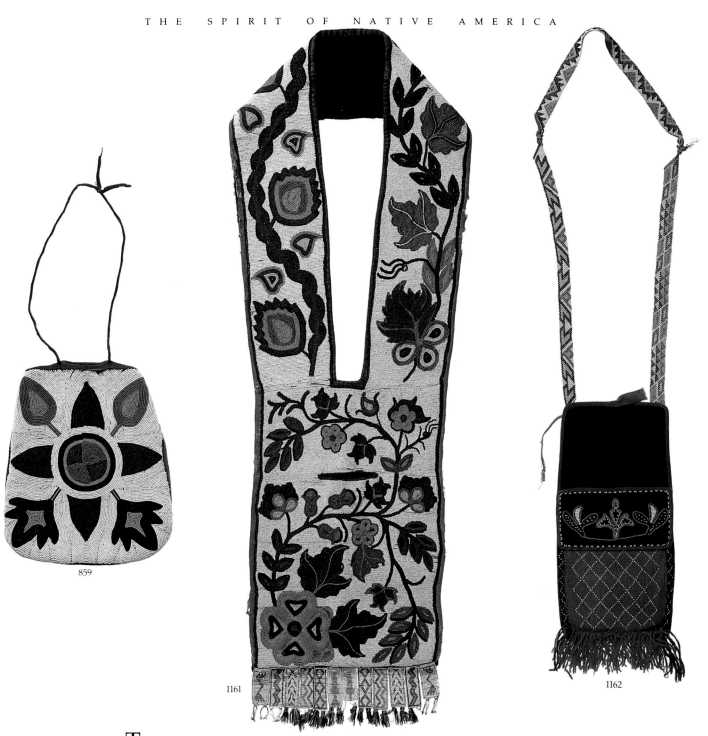

859

1161

1162

The elaborate pouch at left is decorated with seed beads, one of many applied
materials such as porcupine quills, ribbon, and fringe. The center bag, and the two of
similar shape on the opposite page, are called bandolier shoulder bags and were
popular with Eastern Woodlands tribes. The design of these stylish carryalls may have
been inspired by European shoulder pouches.

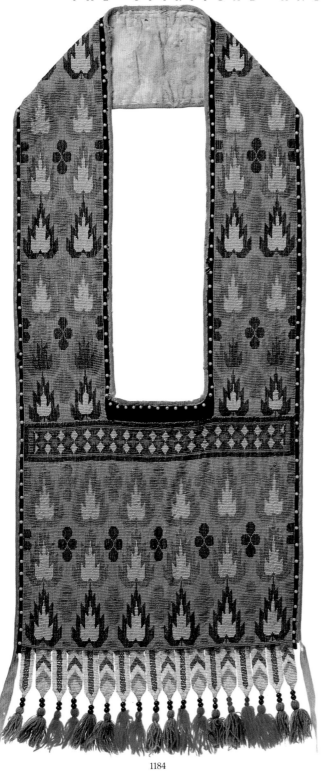

1184

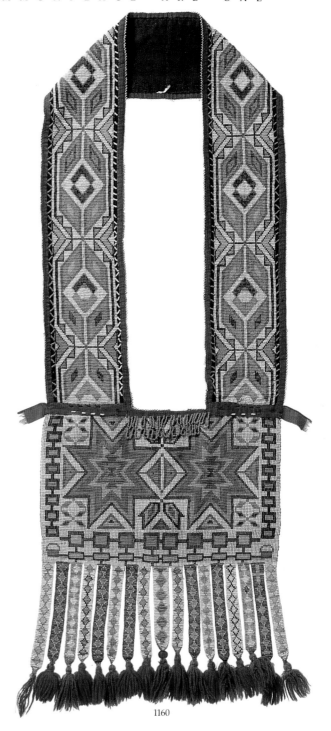

1160

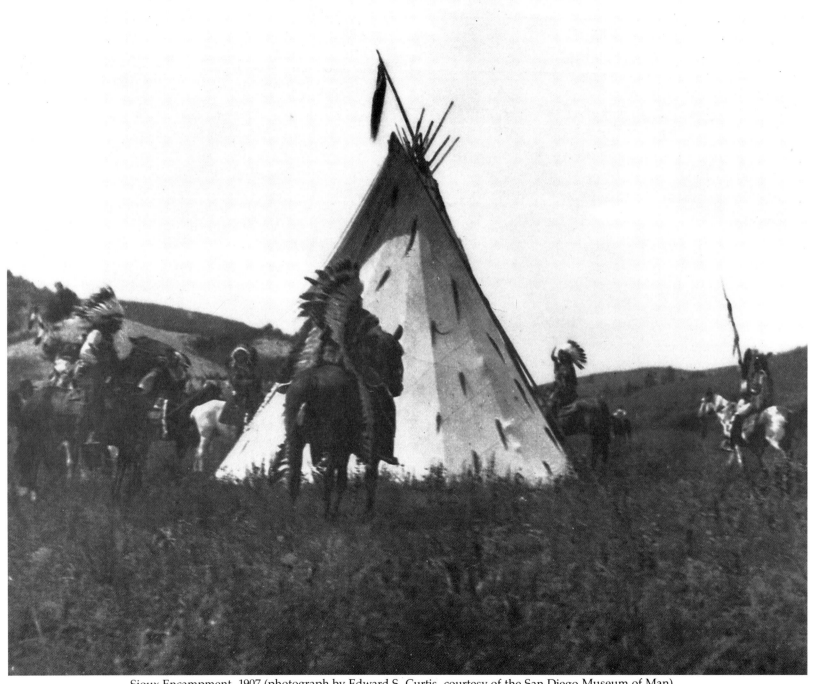

Sioux Encampment, 1907 (photograph by Edward S. Curtis, courtesy of the San Diego Museum of Man).

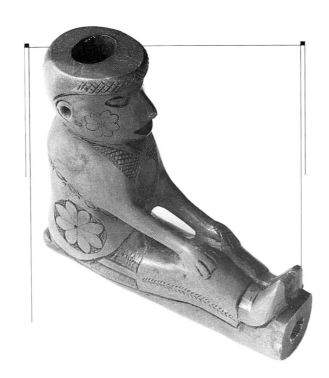

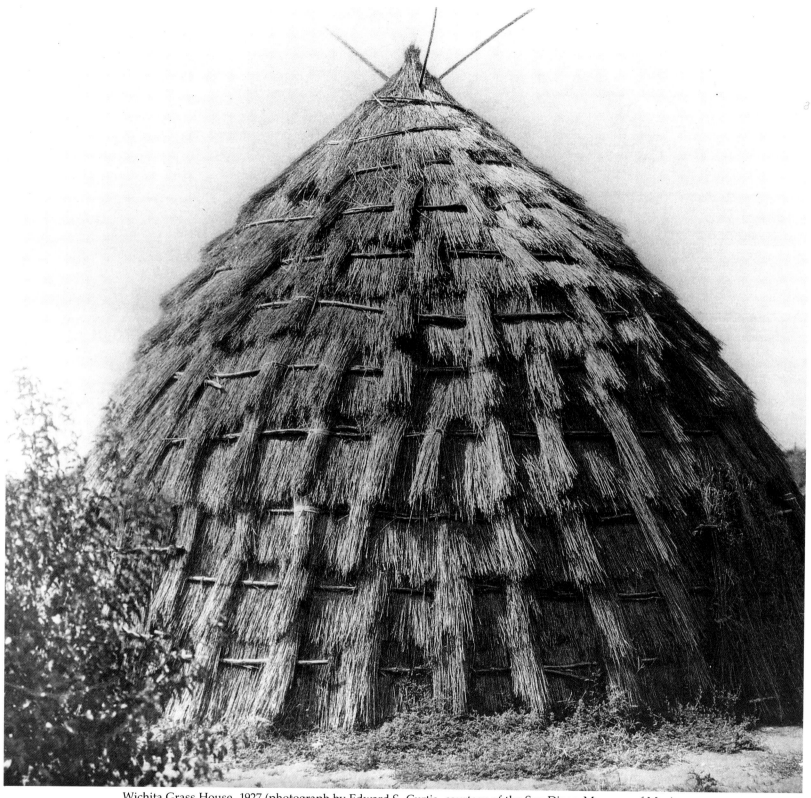

68

Wichita Grass House, 1927 (photograph by Edward S. Curtis, courtesy of the San Diego Museum of Man).

I do not live without beauty. For beauty circulates throughout the cosmos and it is life. My world is created of symbols through which I come to beauty.

My dwellings are round, representing the universal circle of the nations' continuity. Our ancient dwellings are of earth, water, stone, wood, bark, and hide. I construct them as my ancestors did before me, with regard for the four directions, the rising sun, landmarks, tribal migrations, or in relationship to immediate kin, clans, and bands.

The heart of each dwelling is a glowing fire made sacred by its life-giving quality. Without it, the dwelling is incomplete. The fire in each dwelling is the heartbeat of the nations made visible, burning down to embers and exploding into bright flames again. From these most ancient dwellings and sacred fires, everything began. Light and life emanated from fire.

Then the people looked beyond their dwellings and fires and saw something infinitely more than the tangible world. They saw that the spiritual realm is the crystal mirror of the cosmos. What is seen reflects the essence of things not visible in the tangible world. This realm of mystical images is entered through dreams, rituals, and ceremony or through direct con-

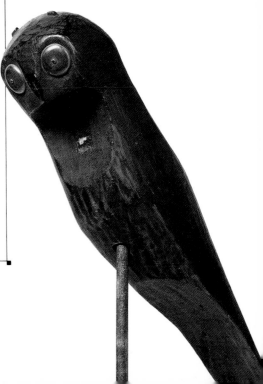

tact with physical things. Dreams come with cosmic force, bringing spirits or symbols to me or leading my own spirit out of me that I might know more. In ritual and ceremony, the nations show me the spirits in literal and figurative ways. Then at times I enter the spiritual realm at its source. I hear the spirit of the wind. I see the spirit of a certain being. And my own spirit soars!

The spiritual realm is where power is stored. It floats freely and loosely about as swirling mystical light and fog, but it is also contained in the forms of all spiritual things. To seek power is to seek spirits. And through spirits the power comes. To seek power is to fuse our spiritual self with another and to transcend all the boundaries of the tangible world.

In my search for power, I do not journey alone. I have guardians and helpers from both realms of the cosmos to accompany me. From the tangible world, I have fire and fetishes of bear, mountain lion, and wolf. I carry the spirit of human ancestors in my weapons of bows and stone arrowheads and in ancient prayers. I wear the protective colors and symbols of my dreams —red streaks on my face and breast to represent the lifeblood in each of us, and a black five-pointed star on my back to indicate the direction and source of my dreams.

With these symbols of my guardians and helpers, I venture out into the physical world to locate the place of spirits and power that I seek. Here I wait, alert to everything and the stillness that surrounds me. Only the clouds move, rolling over the stars in thunderous bil-

lows. The air becomes heavy and damp and light shoots out from the clouds at me. The red streaks on my breast appear to be another color in the thunder light. Bolts of white-hot arrows pierce the night around me and land at my feet! Too close an arrow strikes and the blackness of the star on my back overcomes me.

I step into the darkness of my mind and see myself lying on the ground beneath the flashing light of the clouds. The spirits in the thunder drop down and rush at me and then are quickly gone again. When I wake, this is all I remember. The sky is swept clear and is full of stars, and silver moonlight pours over me. At my side fire burns brightly, soothing my mind and drying my wet hair. I feel the magic stir of the fetishes in the pouch under my arm. And now I know the Thunder Beings for what they are, just as they know who and what I am.

When life ends in the physical world, the human spirit moves on within the great circle of infinity where all spirits are One. This is why we greet everything in the cosmos as our kin, as our ancestors, as our eternal grandparents who brought us forth out of their dreams. This is why I am never alone. I call the earth my mother, the sky my father, the water my grandmother, and the fire my grandfather. I am a cosmic being and infinity is my home.

It is through my symbols of myself and my world that I am known. It is through these ancient symbols that I was born. You may see my ancestors in the dawn, as I see them everywhere. They call me to them and as their child, I go forth to beauty.

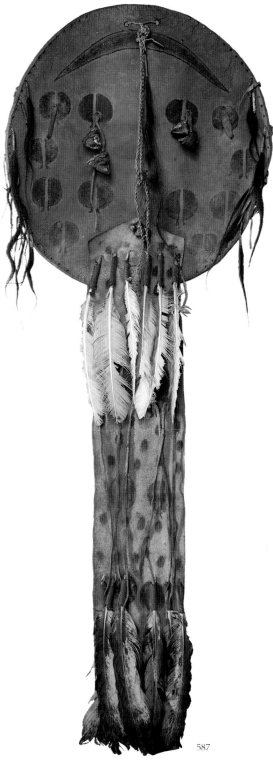

587

Dakota Sioux War Shield, South Dakota, pre-1850 (photograph by Jerry Jacka).

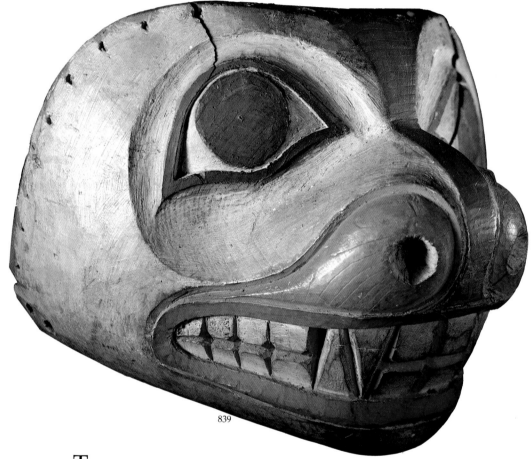

839

Tlingit Bear Mask, Southeastern Alaska, 1875 (photograph by Jerry Jacka).

All tribal societies are linked by similar views of the universe. Among these views is a shared belief that there is more to the universe than what is seen. And it is around this belief that most societies ordered their worlds and interacted with the physical realm.

Masks represent beings that exist in the spiritual component of this world. As ceremonial aids, masks are as powerful as the beings they depict. Because masks emit power that can affect the mind or senses, no one ever speaks through them during ceremonial activities. Sometimes masks represent supernatural healing deities and are used to treat the ill. They are also used to pantomime events in the history of particular groups. Whatever their use, masks are considered sacred objects because they are made according to a strict procedure regulated by each tribe.

Another common way tribes communicated and interacted with the larger world was through the use of pipes and tobacco. The smoke was viewed as a vehicle that carried the thoughts and words of the nations to the spiritual world. In fact, clay and stone pipes were among the earliest objects produced by Native Americans. Pipe bowls were made of heat-resistant stone that could easily be carved; steatite, catlinite, argillite, shale, and limestone were the most common. Readily available clays were also used to make pipes. Eventually, metal pipes were introduced as trade items, but they were not used for smoking. Pipe stems were elaborately carved from wood and decorated with feathers, quills, beads, fur, and horsehair.

When storing a pipe, the bowl is usually separated from the stem because the pipe is viewed as having the qualities of a living being. Among the Lakota Sioux, for example, the pipe bowl is said to signify all people and the stem is said to represent all living things. So when the bowl and stem are joined, the pipe represents the universe.

Wild tobacco was often cultivated by the tribes. Sometimes other materials and herbs were added to it—a mixture called kinnickinnick by the Algonquians. The Southwestern tribes believe that tobacco was one of the four sacred plants given to them at the beginning.

Music is also part of the tribes' worldview, both through songs and in the form of musical instruments. But without the accompaniment of the singer or healer to project the power and meaning of the songs, the instruments cannot be truly appreciated.

Although often mistakenly classified as musical instruments, rattles are also used as healing tools. They are fashioned from gourds, animal hides, hooves, or turtle shells. The peyote rattle, made from a gourd, is used to accompany individual singers.

Drums were created from hollowed-out trees and logs. The largest are powwow drums, around which several singers can sit; the smallest drums are purely decorative.

Sometimes employed as musical instruments, whistles are more often used in ceremonies and for healing. Eagle bone whistles used in the Sun Dance and Native American Church mimic the eagle's cry and imply the presence and power of that great bird.

In their views of the spiritual and physical world, the tribes use symbols freely to enrich their daily lives and ceremonies. The symbols serve as either protection or as reminders of the living universe, bridging the gap between the spiritual and physical realms.

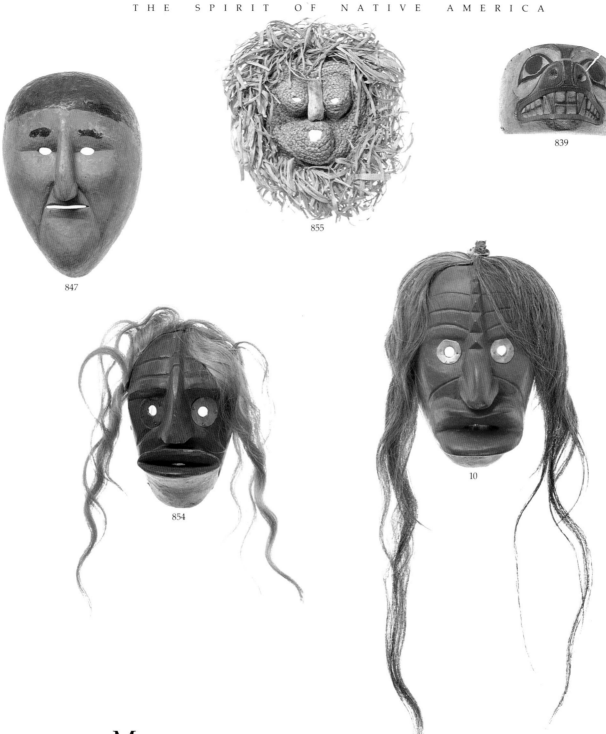

839

847

855

74

854

10

Masks such as these played an important role in tribal ceremonies. The False Face Society of the Seneca used masks like the two with human hair to break evil spells cast by the dreaded False Face spirit. The mask at upper left depicts the Butternut Booger, an alien spirit feared by the Cherokee.

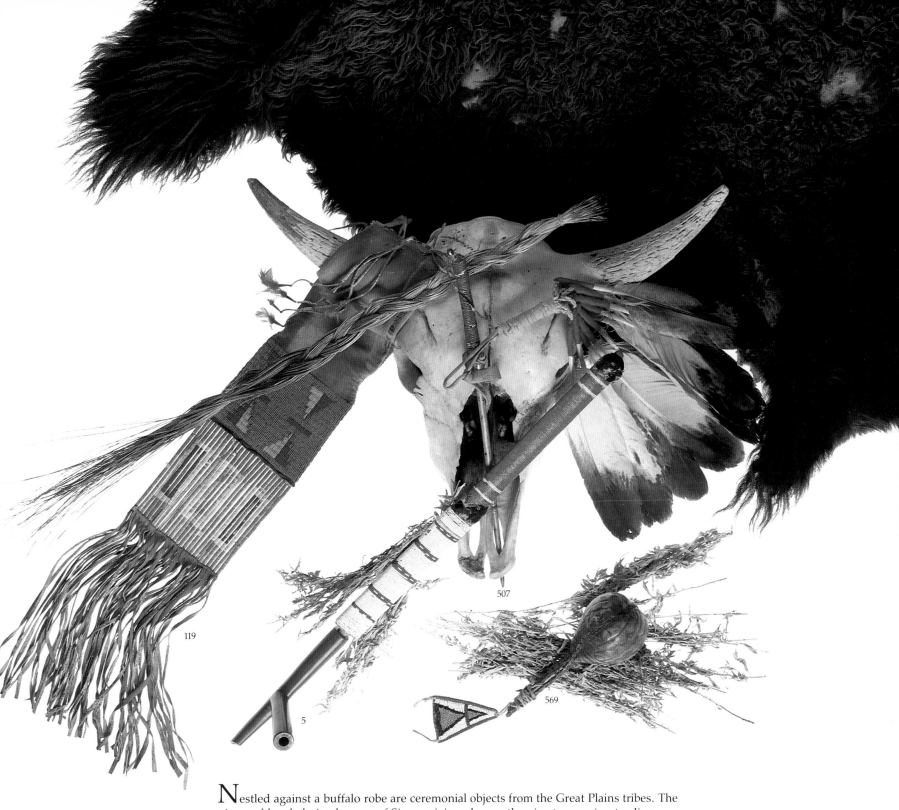

119

507

5

569

Nestled against a buffalo robe are ceremonial objects from the Great Plains tribes. The pipe and beaded pipe bag are of Sioux origin, whereas the pipe tamper (protruding from the buffalo skull) and gourd rattle are Northern Cheyenne. Sweet grass and dried sage made an incense that was burned for purification.

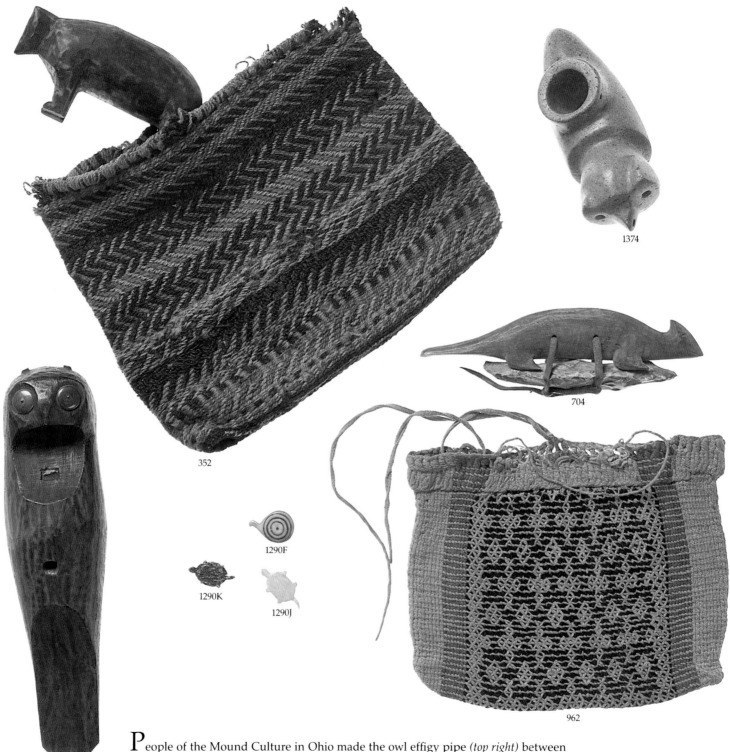

76

1374

352

704

1306

1290F

1290K

1290J

962

People of the Mound Culture in Ohio made the owl effigy pipe *(top right)* between 1000 and 1500 A.D. The bear fetish and bag *(top left)* are Potawatomie. The tiny animal figures at bottom are game counters made by the Menominee of Wisconsin.

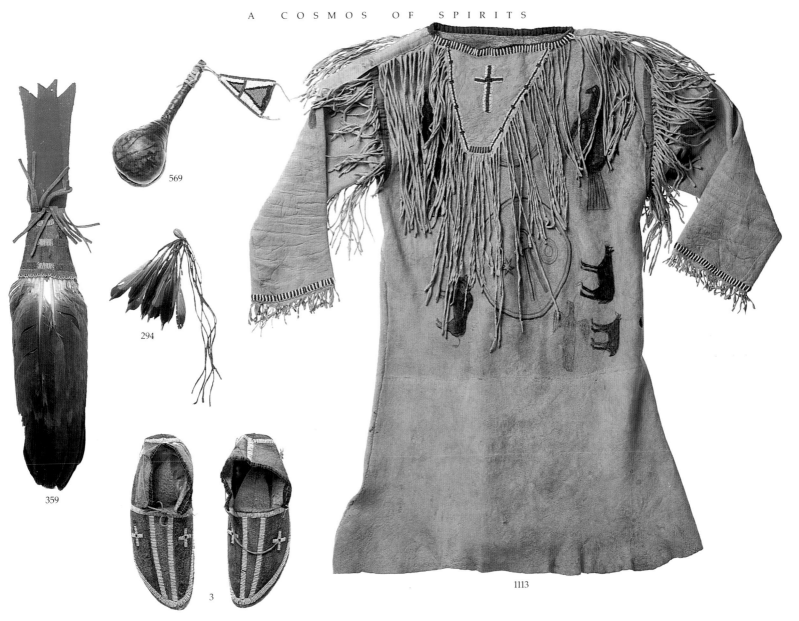

569

294

359

3

77

1113

Shirts like this one of painted buckskin were made for participants in the Ghost Dance, an ill-fated religious movement that ended in 1890. The moccasins and small, feathered hair ornament are Sioux.

78

1

24

1190A

Scalplocks are the predominant decoration on this Sioux war shirt, along with quills, beads, and paint. The garment dates back to about 1890—the year of the infamous massacre of several hundred Sioux by U.S. cavalry forces at Wounded Knee, South Dakota. *Opposite.* Several dozen golden eagle feathers adorn this Crow shield cover. Its maker also included a couple of bear claws and a row of brass bells.

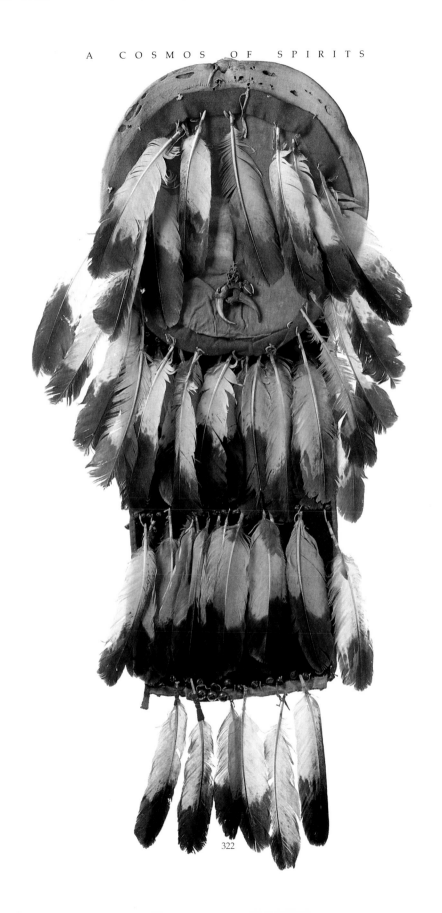

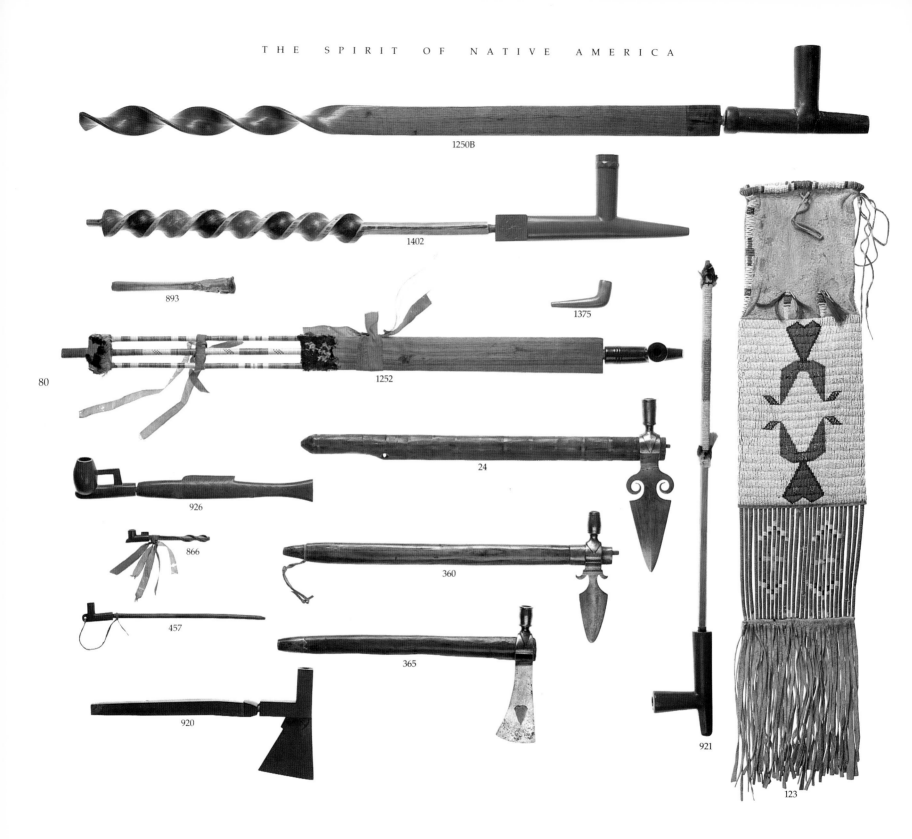

1250B

1402

893

1375

80

1252

24

926

866

360

457

365

920

921

123

114

752

820

Opposite. The practice of pipe smoking among Native Americans was usually conducted in conjunction with some kind of ceremony, peaceful or otherwise. Pipe bowls were carved from heat-resistant stone such as catlinite and steatite; the carved stems usually were made of wood and often elaborately decorated. The metal pipe tomahawks came from Europe as trade items. *Above.* The pipe bag and warbonnet came from the Sioux; the peyote fan of golden eagle feathers was made by the Kickapoo of Oklahoma.

82

1155

1276

585

574

932

598

591

1280

425

603

959

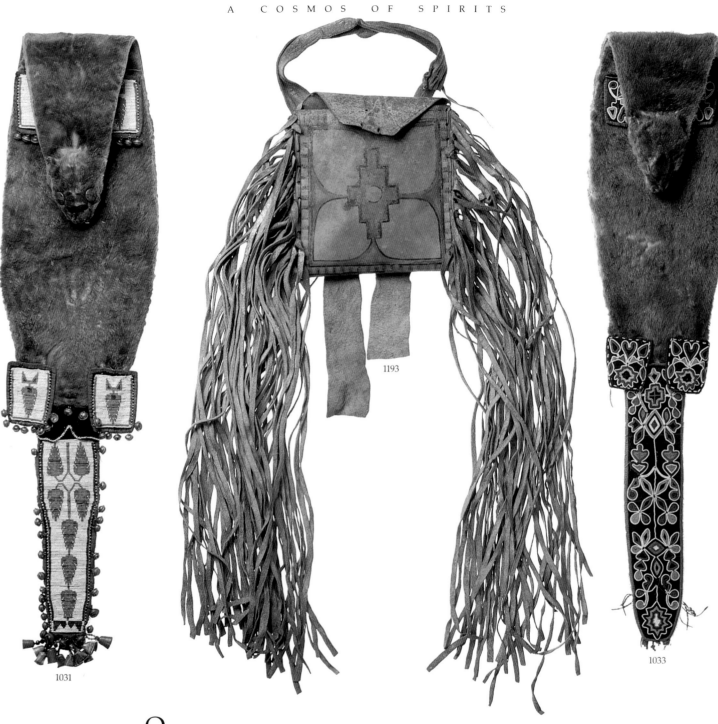

1031

1193

83

1033

O*pposite.* Although most musical instruments were intended for celebration or ceremony, a few had other uses. Flutes like the one at left were played by men of the Dakota Sioux when courting their ladies. And Sioux warriors are reported to have blown shrill eagle-bone whistles during battle to terrify their enemies. *Above.* Beaded otter-skin medicine bags flank a rawhide parfleche decorated with the wind symbol.

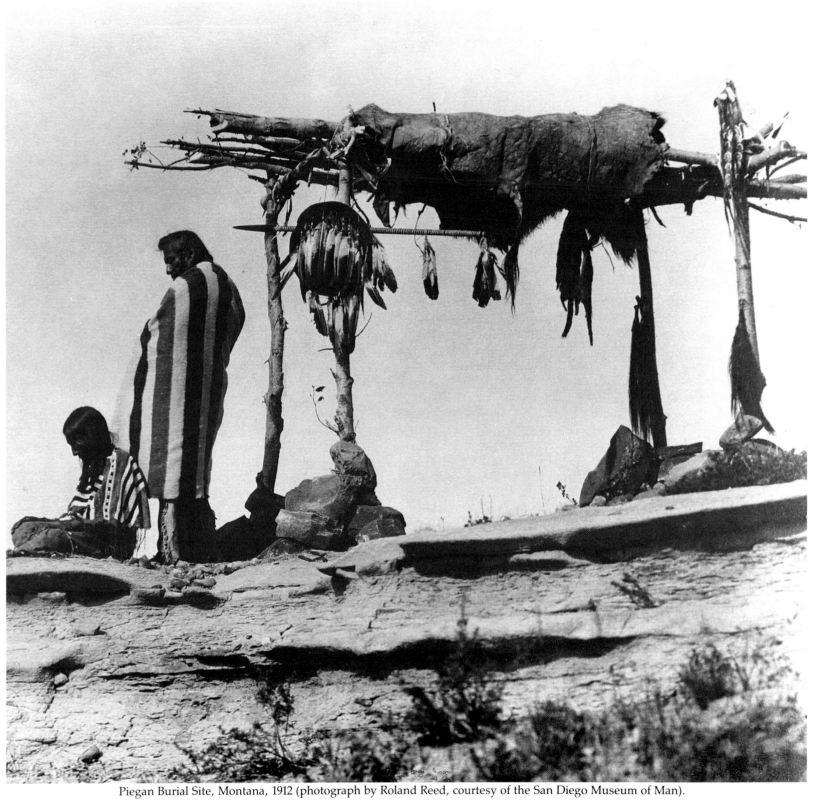

Piegan Burial Site, Montana, 1912 (photograph by Roland Reed, courtesy of the San Diego Museum of Man).

WHAT THE SPIRIT TELLS ME

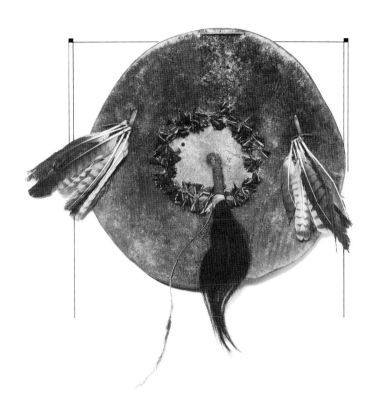

86

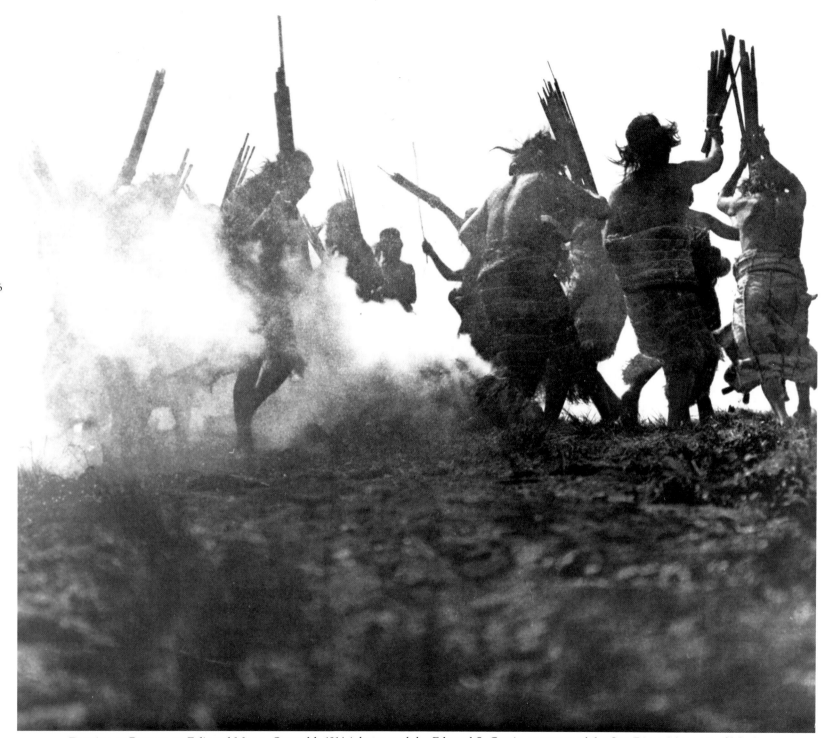

Dancing to Restore an Eclipsed Moon, Qagyuhl, 1914 (photograph by Edward S. Curtis, courtesy of the San Diego Museum of Man).

WHAT THE SPIRIT TELLS ME

O Great Spirit of the Cosmos, You know us by who we are and You speak to us in everything that is. Since time began, the nations have followed You.

Some of us are water people, who listen to the spirit of the sea, of the otter and salmon.

Others are of the desert, who hear your spirit in the rain clouds, in the four sacred mountains, and at the place where people emerged into this world.

Our people of the Plains hear the spirit of the buffalo and of the heavens.

Our people of the Southeast and the gulf hear the spirit of the redbird, of the cypress, of the alligator, of the underworld.

Our nations of the Great Lakes country hear the spirit of the moose, of the hickory, of the great forests.

All the nations hear your spirit in the Earth. It is a woman spirit, we think, who says to us: This is sacred land. Of earth our bodies are composed and to this Mother Earth our bodies will return.

We hear your voice everywhere—it is loose in this world! Even as we sleep, the spirit slips through to us in dreams. And as we follow the spirit wherever it leads, it is You we are destined to meet.

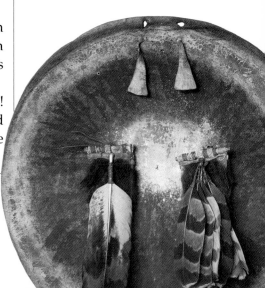

From the day we are born until the day we pass from this physical world, we seek more of your infinite power. And You hear our words and understand our quest. You communicate in ways only we understand. Your power flows through our nations, bringing children, food, health, and ceremonies. Our lives would not be so full of beauty and meaning without these necessities. Seasons would be so much harder to endure. By our attention to your power, as individuals and as nations, we live!

We have long understood the power of women. Through a magic flow regulated by the silver spirit of the moon, children come to us. This is an awesome thing! Alone in their dwellings, the women work magic spells, calling elusive deer to weary hunters. They mend all manner of broken things. These powerful acts have always made the nations strong.

From within the sacred circles, the men gain power and magic. The young men are led to personal power and to the spirit of the cosmos; mature men are advised to seek a protecting spirit who will warn of impending danger. Always, great leaders have deferred to what the spirit tells them.

The keepers of the power are the elders! They alone store and interpret collective knowledge. They are the healers—the medicine people. Without them, the power of the nations would be greatly diminished! Your mystical power flows among the nations in a great crystalline circle of life. And it is this circle of power that is the source of our ancient faith!

That nations were conceived by mystic dreamers,

who interacted with their own dreams, is evidence of this power flow! And creation of the nations by cosmic ancestors—by the stars, the sun, the animal beings in the sacred places of Mother Earth, in the great cosmic void—marked the beginning of our power search! Born of spirit beings, we are compelled to do as the spirit bids—to produce symbols of You, to bring ceremony to You, to heal our bodies and minds, to renew the power of the nations whenever it wanes and flows away.

O Great Spirit of the Cosmos, it is through our prayers, songs, and sacred ceremonies that we venerate You. And we hold in high esteem the keepers of these precious things. Bless the dreamers, the healers, the priests, and the prophets who walk among us, for they must daily pass between the physical and spiritual worlds! They do so, so that ancient power and knowledge will continue to bind the nations as it has for thousands of years. They do so, so that the nations might live! Without them, our nations would disintegrate, our cosmic vision narrow. And the physical world would become the focus of our dreams.

It is our healers who attune us to the spirit of the cosmos. They treat us with herbs to restore our bodies and with songs and prayers to soothe our restless minds. They remind us of our own unique power to live in harmony with all other beings.

It is our priests who conduct rites and ceremonies to make tangible the spiritual realm for all to see. They care for our most cherished material possessions—the sacred bundles that contain objects endowed with inherent

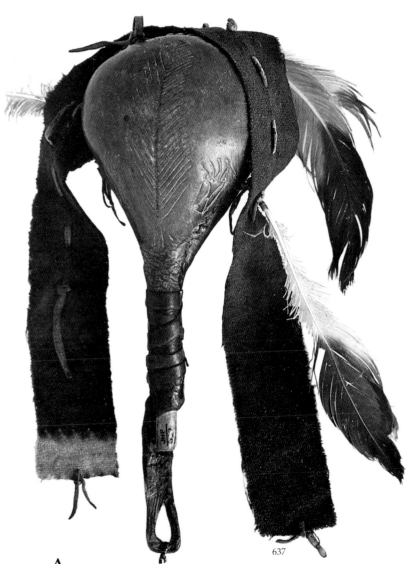

637

Arapaho Rattle, Wyoming, ca. 1850 (photograph by Jerry Jacka).

powers. The bundles are spiritual beings. They are *alive*. Our priests dedicate their lives to caring for these sacred bundles and in return, the bundles give back life and meaning to our existence.

It is our prophets who give us new ideas and new hope. They always voice what You say, revitalizing the nations at ebbs in our existence. Through them, we joined hands in the Ghost Dance, dressing accordingly as once again we gave ourselves over to a collective dream. When the peyote spirit spread across this sacred land, some of us heard and followed.

O Great Spirit of the Cosmos, hear our prayer. With it, we burn our offerings of sweet grass and cedar to join the scent and smoke of the sacred tobacco as it carries our words to the sky. Once again, we want to say we venerate the spirit of life that is everywhere. And for the moment, this will be the end of our prayer, even though we know that everything we do as long as we live is an unending prayer to You.

Look at us then with tenderness and compassion. We are your cosmic children—ancient nations of spirit seekers who have lived thousands of years. In beauty may we continue to live.

89

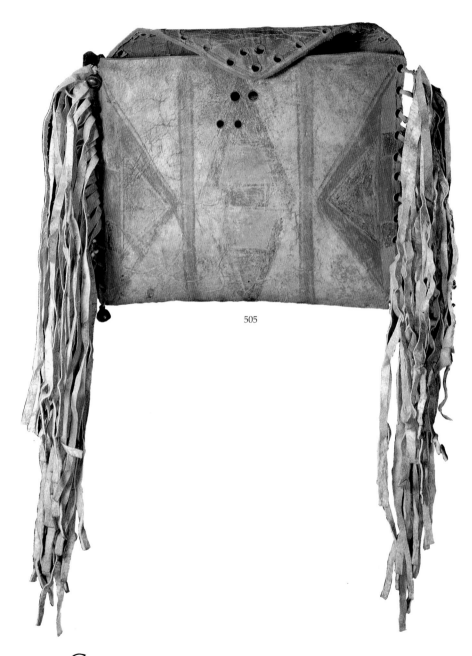

505

Crow Medicine Bag, Montana, pre-1850 (photograph by Jerry Jacka).

A s with many terms that describe Native Americans, *medicine man* is not one of their choosing. French trappers first used the term to identify male religious leaders and healers, although women also filled this role in many tribes. In any event, medicine, religion, and ceremony permeated daily tribal life. Ceremonies were held to heal tribal members, to mark seasonal activities, to recognize milestones in a tribal member's life (or in the life of a tribal group), and to renew a group or person. These activities could range from individual rituals to ceremonies in which the entire tribe participated and they could last from a few minutes to several days. Whatever the duration and occasion for the ritual, some kind of ceremonial paraphernalia was always necessary.

Certain ceremonial items also symbolized social rank; the highly prized bear claw necklace is a prime example. Horned headdresses and eagle feather fans implied both social and supernatural powers and were therefore used only by warriors, medicine people, and chiefs. In the Prairie and Woodlands tribes, leaders were distinguished by their otter skin hats decorated with beads or metal ornaments.

All tribes practiced healing and in these ceremonies, a variety of sacred objects were used—dolls, fetishes, fans, eagle talons, feathers, masks, pipes, rattles. These objects, believed to contain curative powers, are still used today. Weasel skin, for example, protects against illness, and some Sioux women wear beaded turtle charms to enhance fertility. Thus, when considering traditional tribal religions, it is unrealistic to think of them in the past tense. Among some twentieth-century Native American tribes, the ancient patterns of ceremonial life and religious activity remain unbroken.

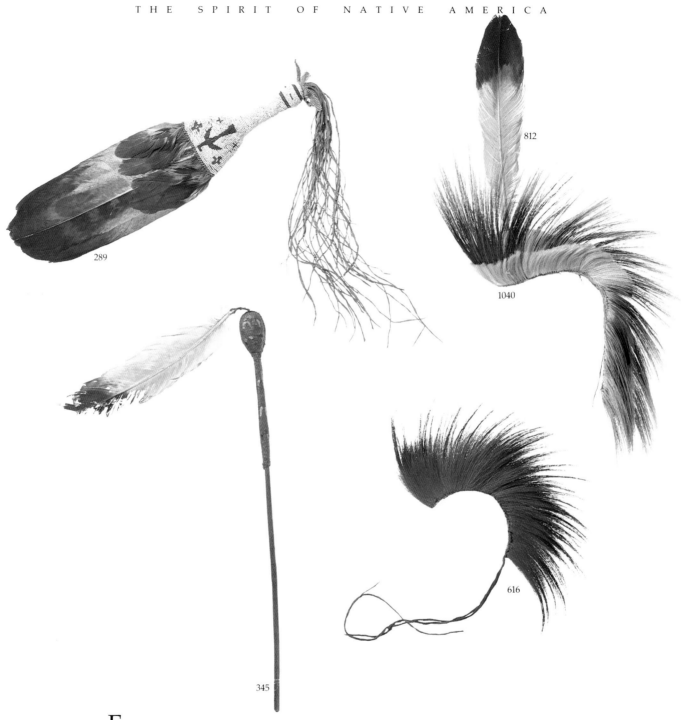

812

289

92

1040

345

616

Flamboyant "roaches" like the two above were fashioned from deer tails or stiff moose or porcupine hair and were worn for ceremonial dancing. After first threading a lock of hair through the front of the roach foundation, a warrior secured the device by tying a buckskin thong around his neck to hold down the back. The wand and eagle feather fan were also reserved for ceremonial use.

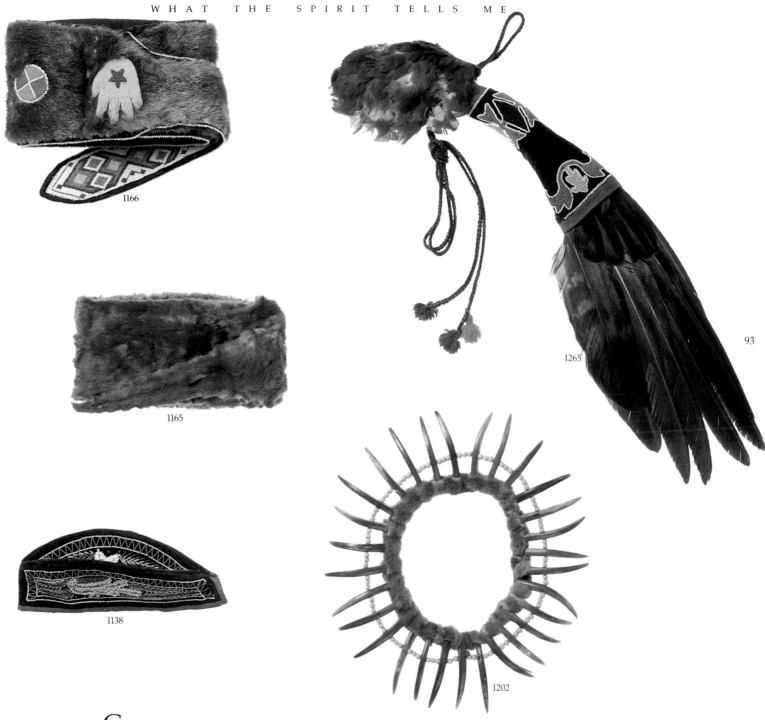

1166

1165

1138

1265

93

1202

Grizzly bear claws and golden eagle feathers were considered powerful medicine by most Indian tribes. Bear claws typically were made into necklaces, whereas eagle feathers had many decorative uses. The eagle wing fan above with the braided yarn tassles and beaded hand grip is from the Sauk and Fox tribe.

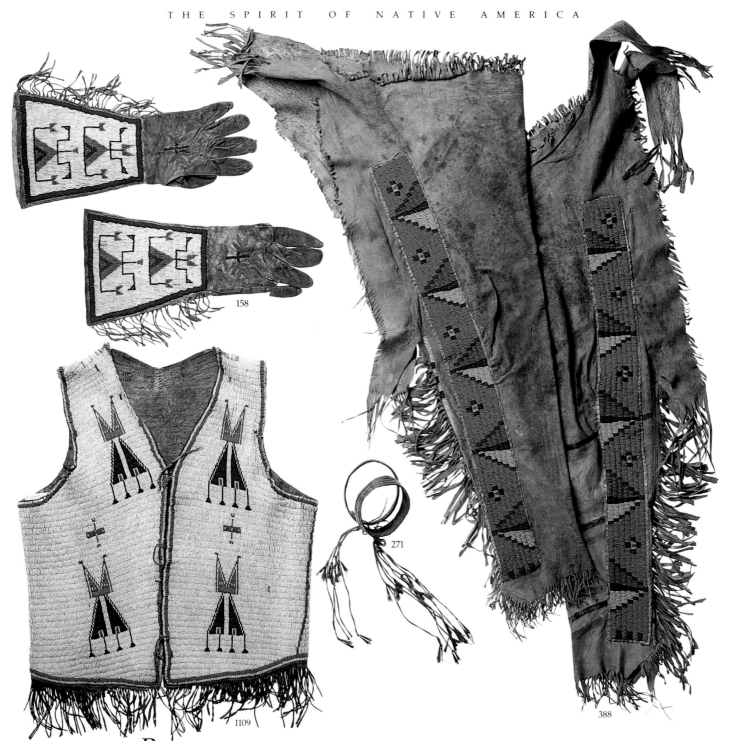

158

94

271

1109

388

Buckskin was the foundation material used by the Sioux on these items of apparel.
The man's leggings date to about 1880 and the quill armbands with tin cones and purple
feathers probably date to about 1810.

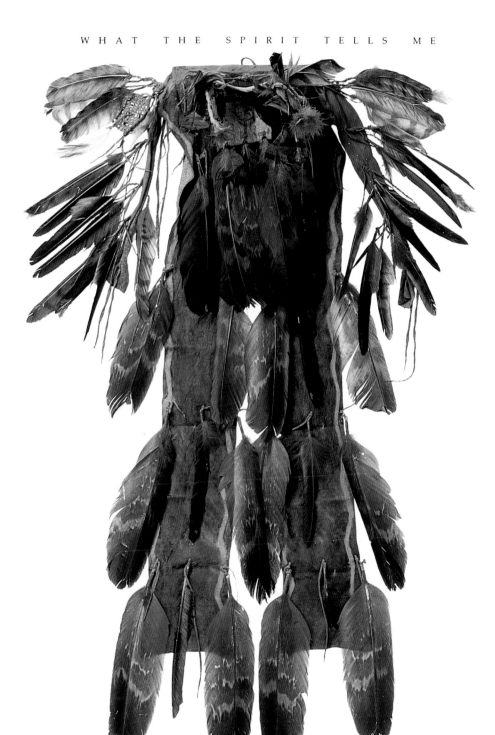

625

Warriors of several Plains tribes wore these feathered "bustles" while performing the Grass Dance, a ceremony that took place both before and after battle. Some of the feathers on this Arapaho version are golden eagle; others are from birds that scavenged the battleground.

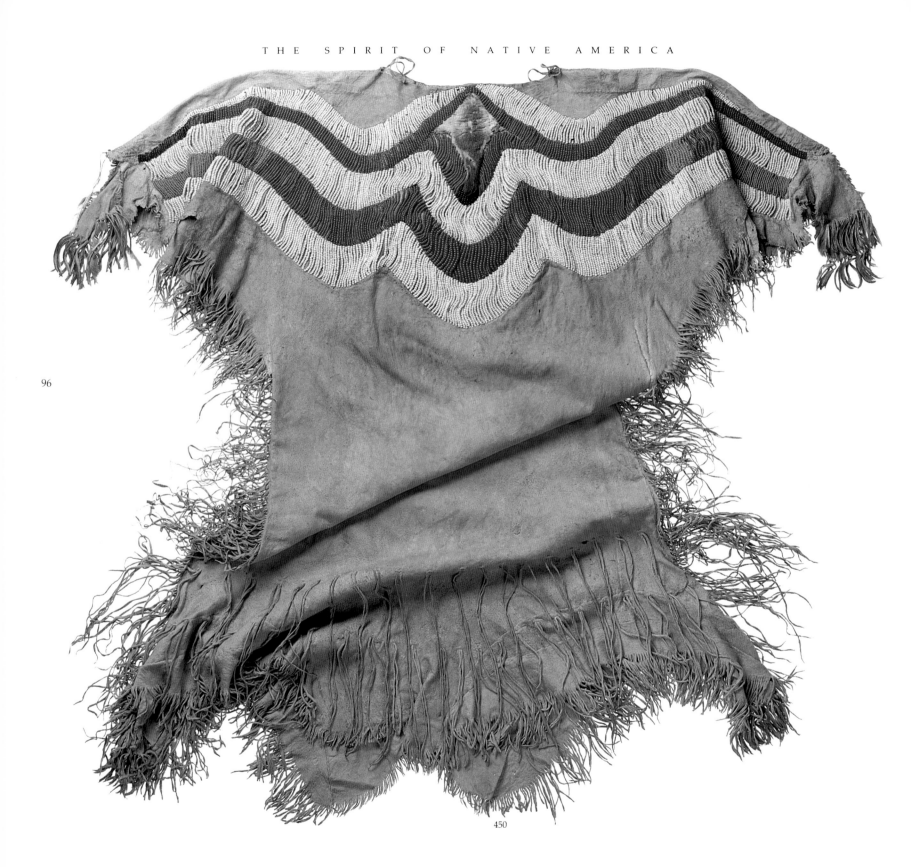

450

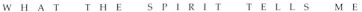

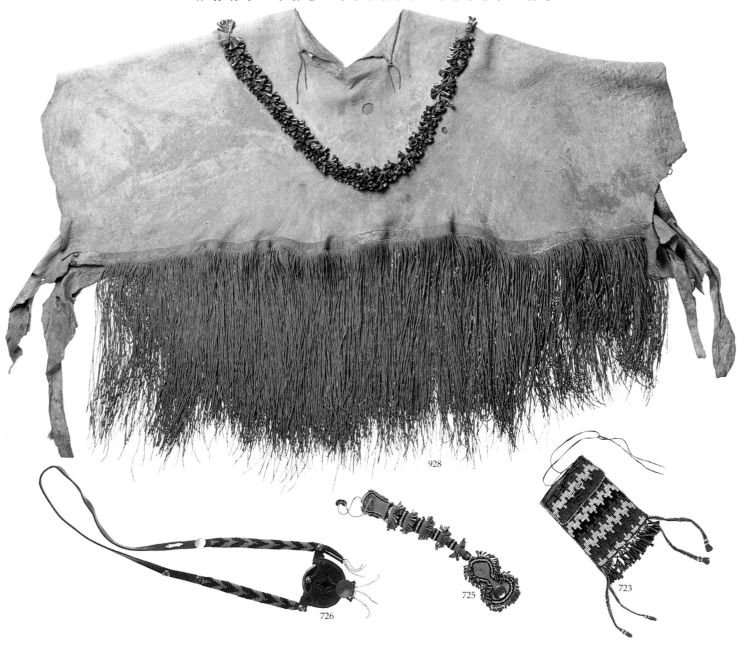

928

726

725

723

97

*O*pposite. Extensive fringing and beadwork are displayed on this traditional buckskin dress made by the Nez Percé in about 1840. Still intact on the garment is fur from the tail of the animal from which it was made. *Above.* A sewn-on "necklace" of tin cones is the only embellishment on this fringed buckskin dress top made by the Apache. The other objects—a woman's pouch, an awl case, and a mirror case—are also Apache.

98

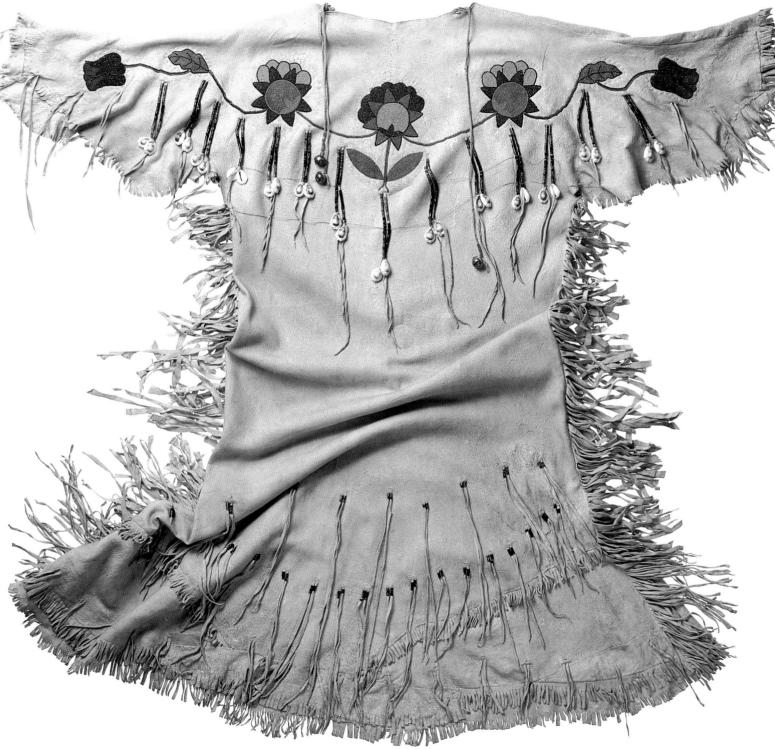

1394

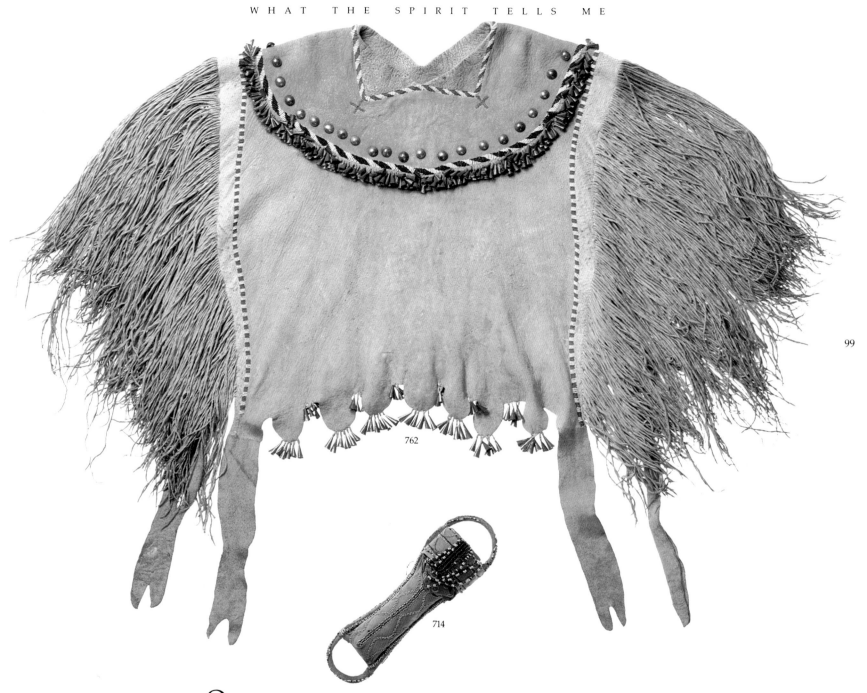

762

714

O*pposite*. Although floral designs such as this originated with Eastern Woodlands tribes, this decorative motif found its way west in the early 1800s. By 1910, when this dress was made by the Nez Percé, it was commonly found in the art of the Plains and Plateau tribes. Beads, bells, and cowrie shells also decorate the garment. *Above*. Subtle colors and simplicity of design characterize this Apache woman's cape, which is also adorned with beaded strips and tin cones. The miniature cradleboard once belonged to an Apache girl.

100

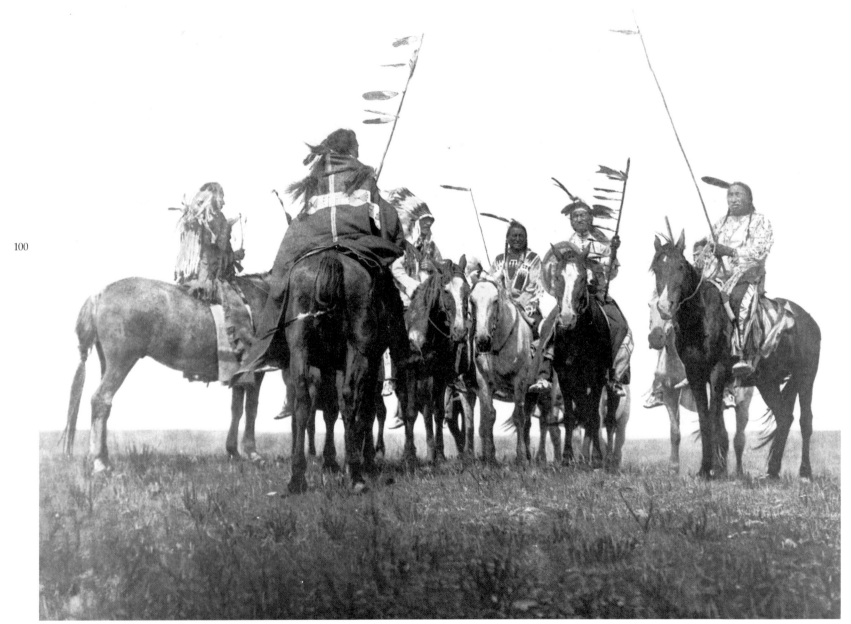

Atsina Warriors, 1908 (photograph by Edward S. Curtis, courtesy of the San Diego Museum of Man).

From earliest times, most Native American tribes engaged in warfare among themselves and eventually, of course, with the European settlers. Warfare was a means of protecting or acquiring lands and goods and avenging deaths caused by enemies. Because the tribes were so varied in cultural beliefs and language, they were often attacked by groups who were extremely different or who competed for territory. Some tribes warred for hundreds of years.

Among the Plains tribes, a warrior "counted coup" (pronounced "coo") on his enemy by touching him with a hand, weapon, or coup stick. This was considered the ultimate act of bravery in warfare. Later, stealing an enemy's horses also won honor and prestige for a warrior.

Sticks or clubs were often used as identifying symbols of societies organized within a tribe. Most of these societies were composed of men who assumed certain responsibilities in hunting and maintaining order in a camp or village.

In historic times, the Plains tribes recognized achievements in warfare in numerous ways. Men and women who had participated in a successful raid or attack or who had defended the village or camp could change their names in commemoration of the event. Sometimes battles were recorded in ceremonies or songs.

Siouan groups accumulated eagle feathers for their deeds, and trailing "warbonnets" were worn by their most daring and successful warriors and war leaders.

Warfare was never undertaken without prior ceremonies and the taboos associated with successful wartime activities were strictly regarded. Warriors always left for battle with the thought of not returning, with the contemplation of their own death. Consequently, they often took along personal power items for protection and strength. Many war parties included a medicine person to aid and advise them.

In the earliest times, warriors went into battle without decoration, painted faces, or clothing. They believed the unadorned body would have a better chance of recovery from wounds, whether minor or serious. Over time, however, this belief changed.

Since warriors were not expected to return from battle, their reappearances were occasions of great joy. After battle, the warriors often stopped a short distance from their camp or village, painted their faces, and donned their most resplendent finery. Usually a welcoming group awaited them and a period of rejoicing followed to honor those who were fortunate enough to return.

102

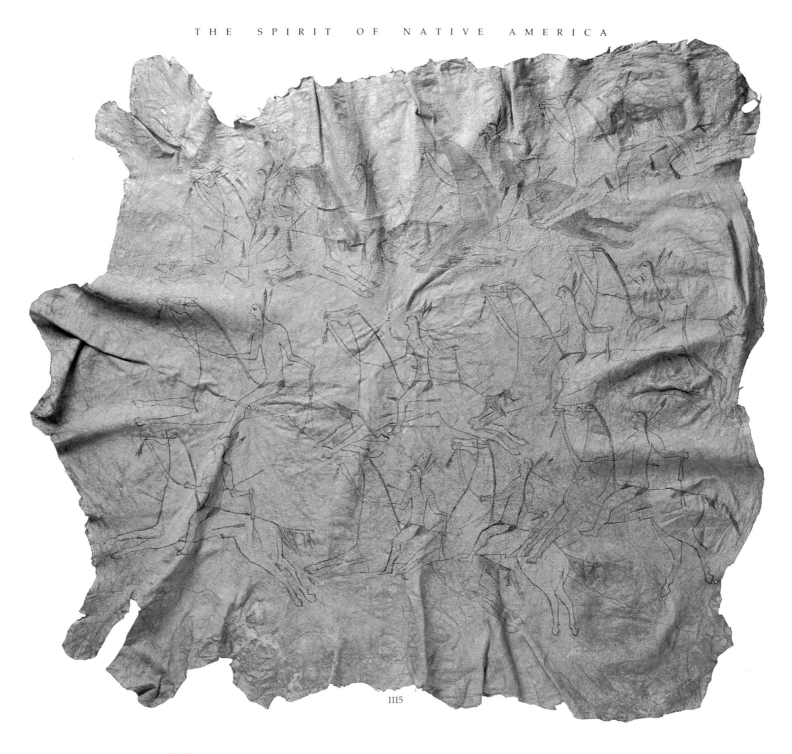

1115

H ide painting was done by both men and women of the Plains tribes, but only men did figurative works showing exploits in battle and other historical events. A geometric design on an animal skin would indicate that it had been painted by a woman.

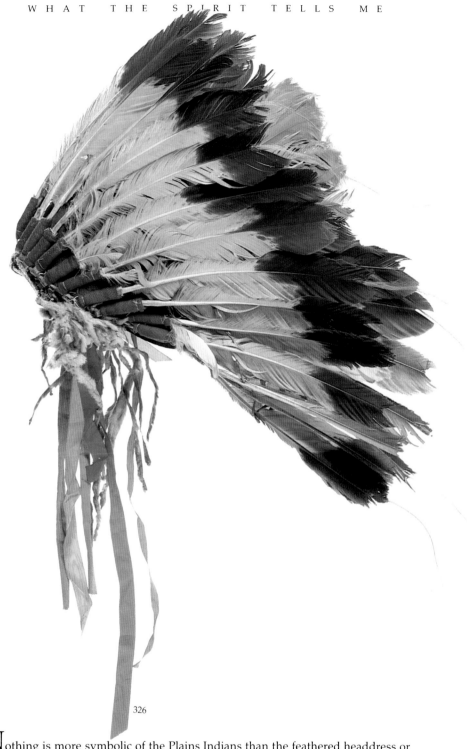

326

Nothing is more symbolic of the Plains Indians than the feathered headdress or warbonnet. Typically worn by chiefs and other high-ranking officers in tribal military societies, this eagle-feathered headgear signified a warrior's prowess in battle and is believed to have originated with the Sioux.

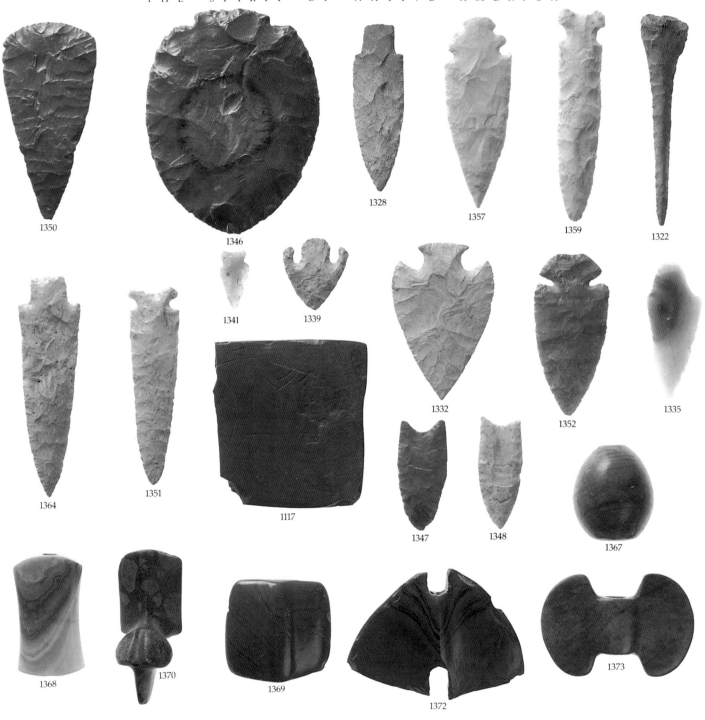

1350

1346

1328

1357

1359

1322

104

1341

1339

1332

1352

1335

1364

1351

1117

1347

1348

1367

1368

1370

1369

1372

1373

Most of these primitive objects are identified with the people of the Mound Culture who inhabited North America between 1000 and 1500 A.D. The lone exception is the slab of reddish catlinite (1117) that came from the Dakota Sioux around 1875.

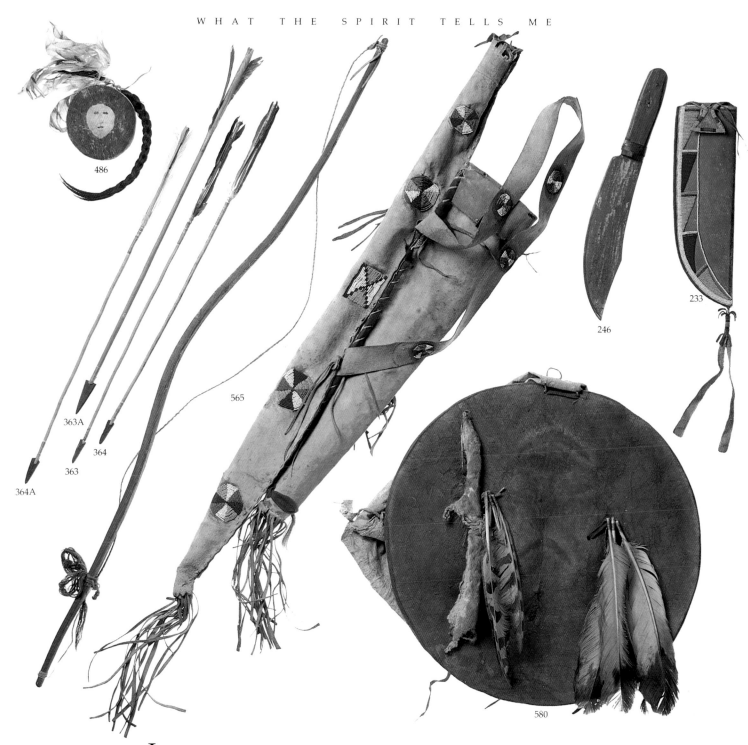

486

363A

364

363

364A

565

246

233

580

Indian men attached symbols of power, or good medicine, to their shields to protect them from harm in combat. A Crow warrior made this buffalo hide shield to which he fastened owl and eagle feathers and an ermine pelt. The miniature shield *(upper left)* is also Crow and is adorned with owl feathers and a plait of human hair.

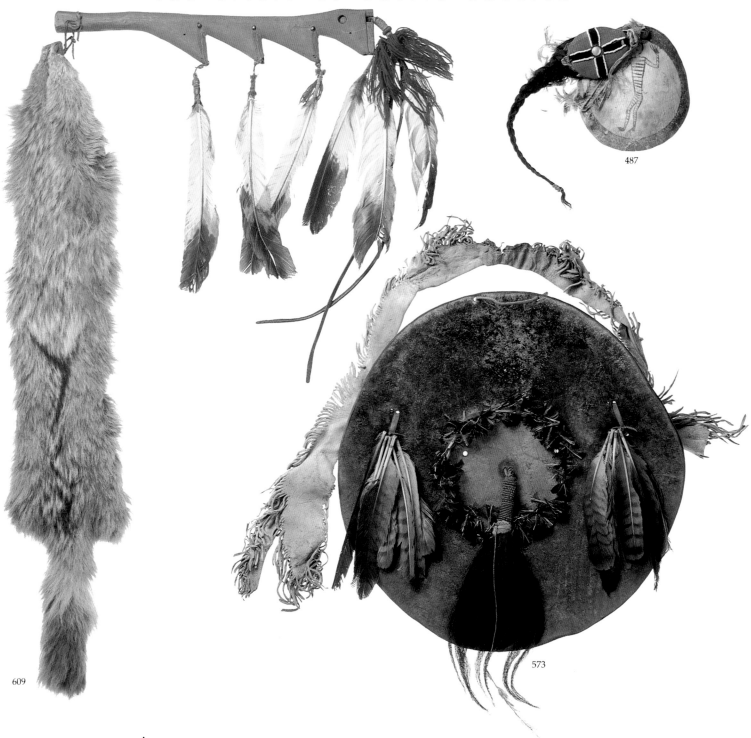

106

487

609

573

A coyote pelt and golden eagle feathers dangle from the saw-toothed wooden handle of this Blackfeet riding quirt. Medicine shields, like the one at upper right, were made to be carried into battle as protective amulets.

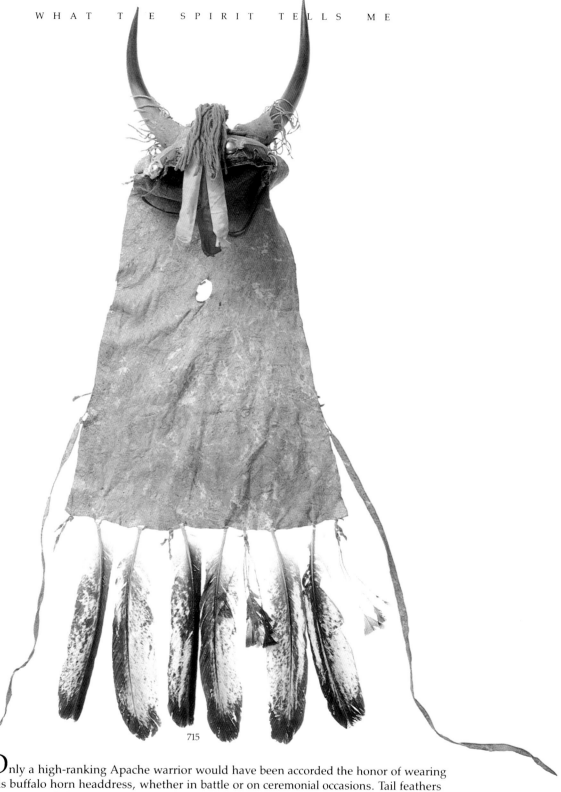

715

Only a high-ranking Apache warrior would have been accorded the honor of wearing this buffalo horn headdress, whether in battle or on ceremonial occasions. Tail feathers of immature bald and golden eagles form the fringe.

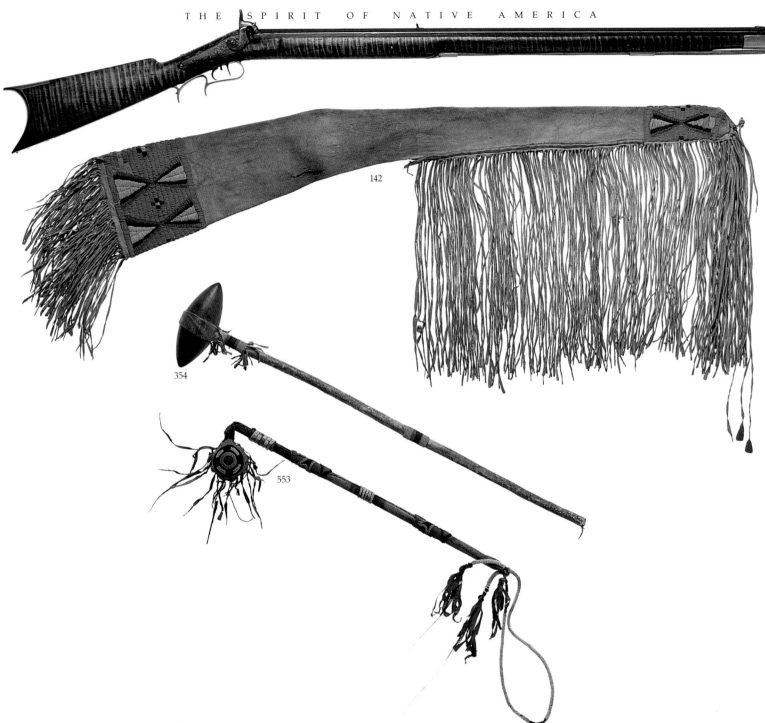

108

142

354

553

The introduction of firearms changed the nature of Indian warfare, but hand-to-hand fighting still required more primitive weapons like these war clubs. The double-headed stone club is of Sioux origin as is the rifle case above it. The club at bottom consists of a beaded, buckskin-wrapped ball attached to a wooden handle.

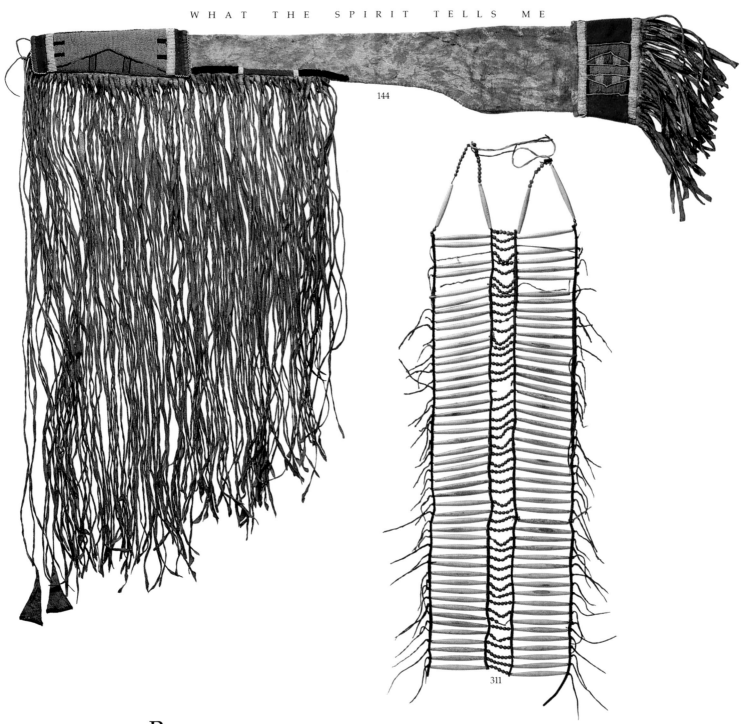

144

311

Below the heavily fringed rifle case is a breastplate constructed of "hair pipes," so named because they were first worn as hair decorations. These tapering cylindrical ornaments were originally made from conch shells, but later commercially manufactured bone was used. Most Great Plains tribes wore these protective devices; this example came from the Brulé Sioux.

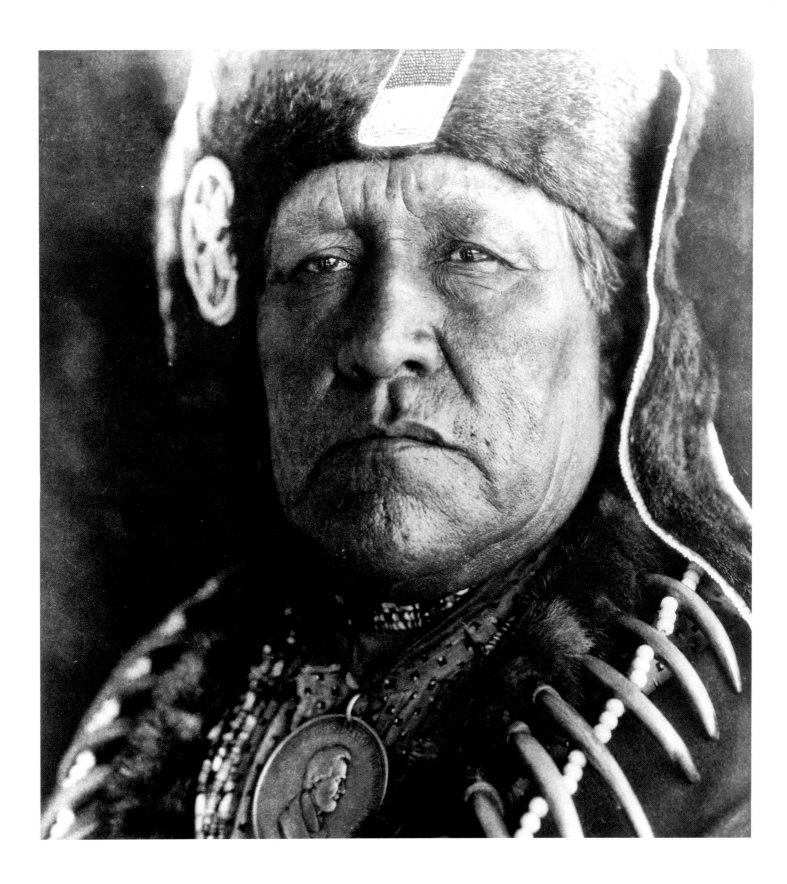

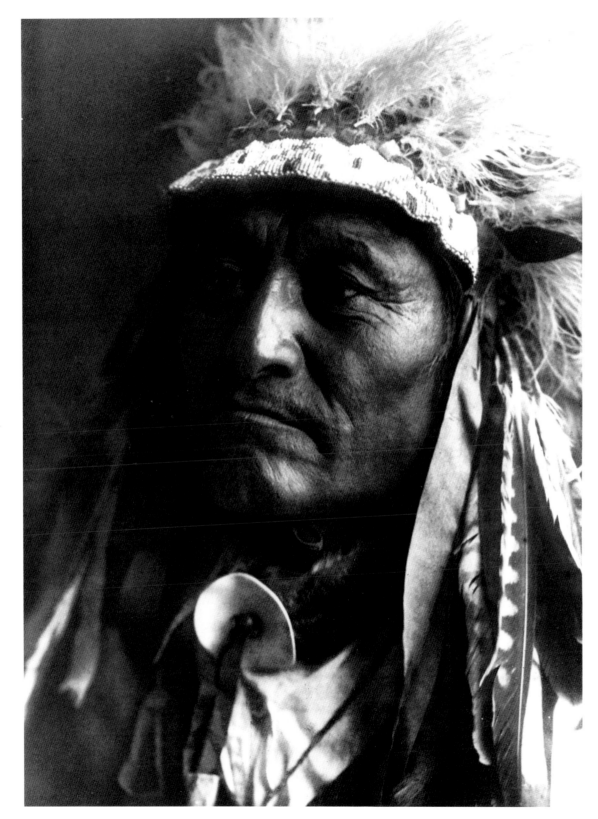

O *pposite:* Old Eagle, Otoe, 1927; *Right:* Crazy Thunder, Oglala Sioux, 1907 (both photographs by Edward S. Curtis, courtesy of the San Diego Museum of Man).

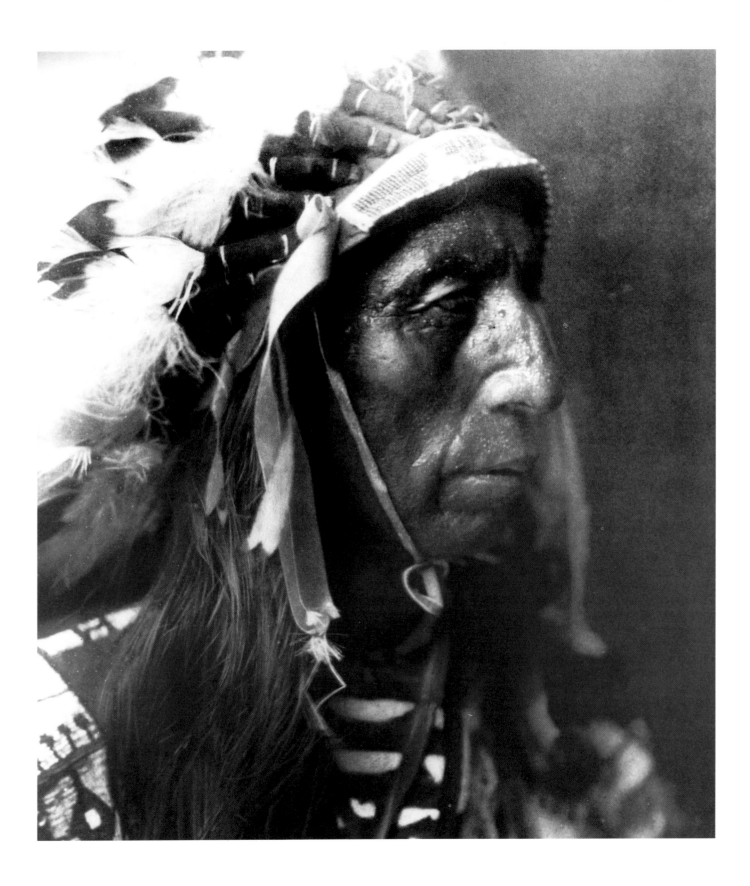

112

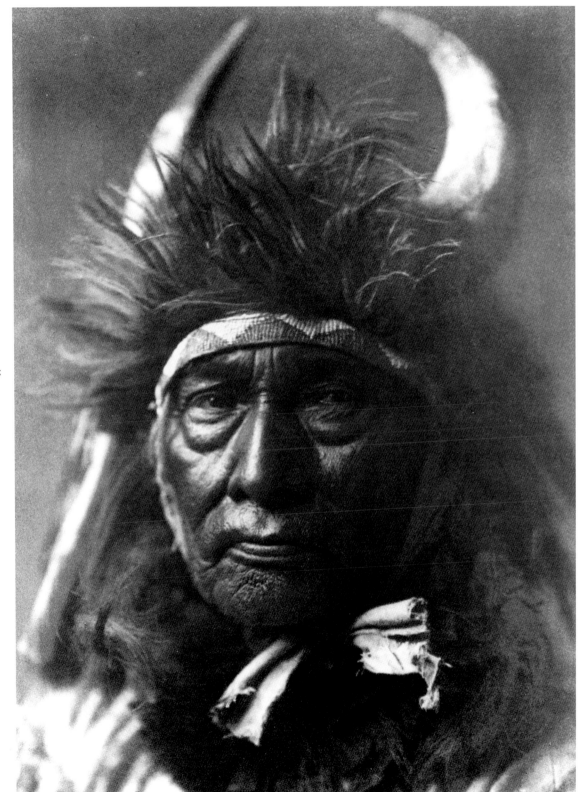

*O*pposite: Jack Red Cloud, Oglala Sioux, 1907; *Right:* Bull Chief, Crow, 1908 (both photographs by Edward S. Curtis, courtesy of the San Diego Museum of Man).

114

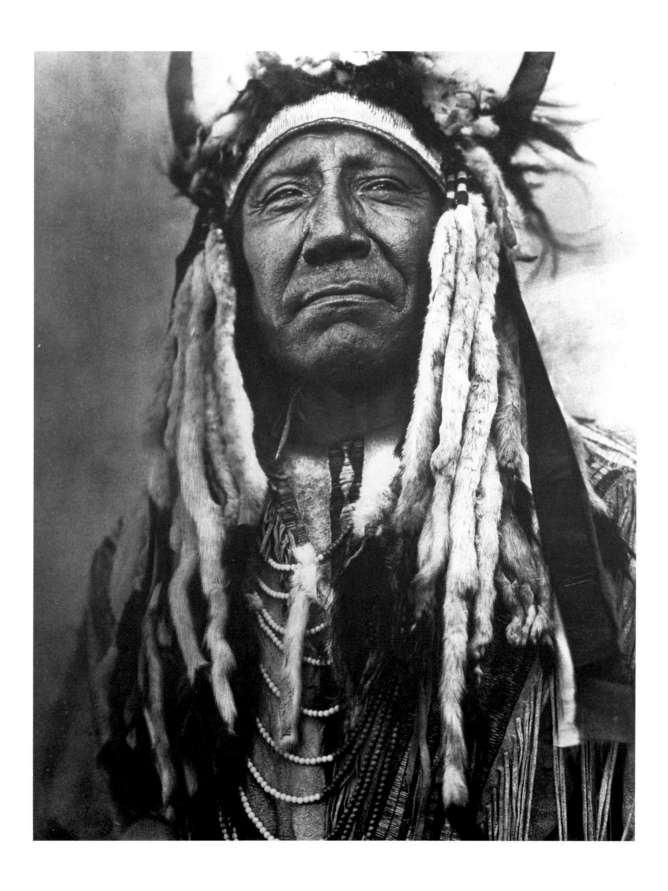

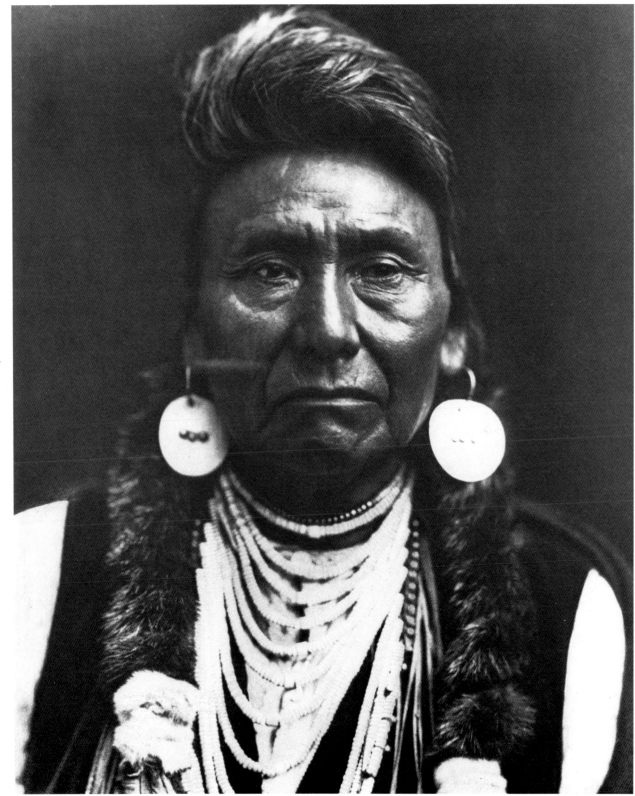

O*pposite:* Two Moon, Cheyenne, 1910; *Right:* Chief Joseph, Nez Percé, 1903 (both photographs by Edward S. Curtis, courtesy of the San Diego Museum of Man). In an eloquent surrender speech in 1877, Chief Joseph delivered these now-famous lines: "Hear me, my chiefs! I am tired; my heart is sick and sad. From where the sun now stands, I will fight no more forever."

116

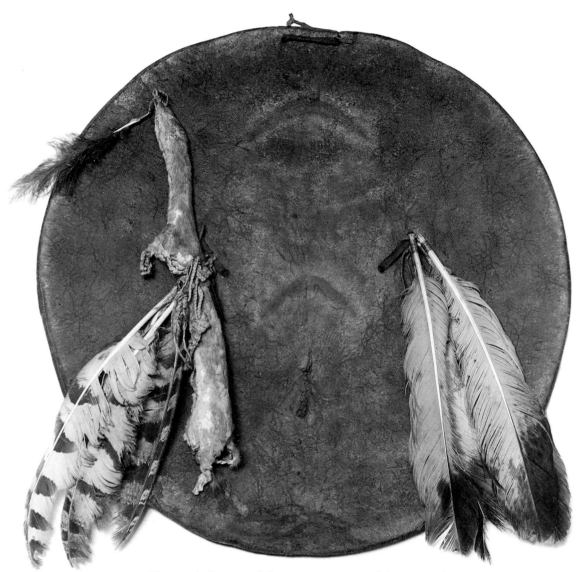

*The earth does not belong to man, man belongs to the
earth. All things are connected, like the blood that unites one
family. This we know.*

CHIEF SEATTLE

NOTES

1. Frances Densmore, *Teton Sioux Music,*
Bulletin no. 61 (Washington, D.C.: Bureau of
American Ethnology, 1918).
2. Black Elk, *The Sacred Pipe. Black Elk's Account
of the Seven Rites of the Oglala Sioux,* ed. Joseph
Epes Brown (Norman: University of Oklahoma
Press, 1953), 115. Used with permission.
3. Dee Brown, *Bury My Heart at Wounded Knee*
(New York: Holt, Rinehart, and Winston,
1972). Used with permission.
4. Stanley Vestal, *Sitting Bull: Champion of the
Sioux* (New York: Houghton Mifflin, 1932),
256–57.
5. Virginia Armstrong, *I Have Spoken: American
History Through the Voices of the Indians*
(Chicago: The Swallow Press, 1971).
6. John G. Neihardt, *Black Elk Speaks,* copyright
John G. Neihardt Trust, published by the
University of Nebraska Press and Simon and
Schuster, Pocket Books, 1972, 230. Used with
permission.
7. T. C. McLuhan, *Touch the Earth: A Self-
Portrait of Indian Existence* (New York:
Outerbridge and Lazard, 1971; Simon and
Schuster, Pocket Books, 1972), 30.

Two of this book's section titles (The Spiritual
and Commonplace Are One, and What the
Spirit Tells Me) were borrowed from Richard
Erdoes, *Lame Deer: Seeker of Visions* (New York:
Simon and Schuster, 1971).

Photographs on pages 13, 25, 33, 35, 67, 69, 85
87, and 116 are by Jerry Jacka.

BIBLIOGRAPHY

Akwesasne Notes. *A Basic Call to Consciousness.*
New York: Akwesasne Notes, 1978.
Armstrong, Virginia. *I Have Spoken: American
History Through the Voices of the Indians.*
Chicago: The Swallow Press, 1971.
Beck, Peggy V., and Anna L. Walters. *The
Sacred: Ways of Knowledge, Sources of Life.*
Tsaile, Ariz.: Navajo Community College
Press, 1977.
Black Elk. *The Sacred Pipe. Black Elk's Account of
the Seven Rites of the Oglala Sioux.* Edited by
Joseph Epes Brown. Norman: University of
Oklahoma Press, 1953.
Brown, Dee. *Bury My Heart at Wounded Knee.*
New York: Holt, Rinehart, and Winston,
1972.
Brown, Joseph E. *The Spiritual Legacy of the
American Indian.* New York: Crossroads
Publishing Company, 1986.
Davis, Barbara A. *Edward S. Curtis: The Life and
Times of a Shadow Catcher.* San Francisco:
Chronicle Books, 1985.
Densmore, Frances. *Teton Sioux Music.* Bulletin
no. 61. Washington, D.C.: Bureau of
American Ethnology, 1918.
Houlihan, Patrick, Jerold L. Collings, Sarah
Nestor, and Jonathan Batkin. *Harmony by
Hand: Art of the Southwest Indians.* San
Francisco: Chronicle Books, 1987.
McLuhan, T. C. *Touch the Earth: A Self-Portrait
of Indian Existence.* New York: Outerbridge
and Lazard, 1971; Simon and Schuster,
Pocket Books, 1972.
Neihardt, John G. *Black Elk Speaks.* New York:
Simon and Schuster, Pocket Books, 1972.
Vestal, Stanley. *Sitting Bull: Champion of the
Sioux.* New York: Houghton Mifflin, 1932.

117

118

119